AN EDUCA

MW01412726

A Guidebook for Supporting Students through the **Chill & Spill** Program

WRITTEN BY:

Jeanean Jacobs, MA, ATR-BC, CPC

Steffanie Lorig, Art with Heart

Annie McCall, MA, LMHC

WITH CONTRIBUTIONS BY:

Sherry Burke, Committee for Children

Dartagnan Caliman, Casey Family Programs

Ti Locke

Zandi Salstrom, Art with Heart

Doris Wong-Estridge, Art with Heart

Helga Tirrell

Wendy Sloneker

Madzy Besselaar

Michelle Miller

SPECIAL THANKS TO:

Committee for Children and Canopy LLC

Your purchase enables Art with Heart to meet its mission –to empower youth in crisis through therapeutic books and programs that foster self-expression.

Published by Art with Heart Press, Seattle, WA ©2009. Illustrations and hand lettering by the respective artists in **Chill & Spill**. All photographs ©2009 Art with Heart.

ART WITH HEART

healing kids through creativity

Submit your story!

We invite you to submit stories describing your experiences with Chill & Spill, student successes and/or unique ways you use the book. Please note that stories submitted are subject to editorial approval and will be edited for length and grammar. The aim is to communicate capabilities and benefits of the program to other educators. Please submit your story to: **info@artwithheart.org** or write to us at the address below.

Proceeds from the sale of this book benefit youth in crisis through Art with Heart's programs and books.

PLEASE DONATE TODAY:
Art with Heart | P.O. Box 94402, Seattle, WA 98124-6702
info@artwithheart.org | www.artwithheart.org
phone: 206.362.4047

ISBN 0-9841365-0-9. **An Educator's Companion to Chill & Spill.** Printed in the U.S. ©2009 Art with Heart. All rights reserved. First Printing: May 2009.

TO ORDER THIS AND OTHER ART WITH HEART PUBLICATIONS, PLEASE VISIT
WWW.ARTWITHHEART.ORG

Table of Contents

An Educator's Companion to Chill & Spill

ABOUT CHILL & SPILL

General Theory of Creativity

Creativity is about considering possibilities, generating new ideas, and asking "why not?" – not just "why?" The creative process reveals that there are new opportunities around every corner, allowing us to see beyond self-imposed limitations.

The act of creating art is therapeutic in and of itself. Artists know firsthand that making art can lower stress, soothe, inspire, provide inspiration, and give a sense of purpose and direction. It is a powerful remedy for emotional injury, opening doors to locked-up emotions and strengthening insight and clarity[1] while encouraging communication. Art making also increases confidence, concentration, empathy and positive feelings – all which transfer readily into other areas of life.

Creative expression's innate therapeutic qualities help increase brain function by simultaneously activating the brain, as well as the physical, emotional and intellectual processes.[2] At the same time, it integrates both left-brain logic and right-brain intuition. As the right-brain works with images, intuition, imagination, emotions (nonverbal memory recall), the left-brain specializes in analytical thought, logic, language and words. A conversion from thought and feeling into art allows new patterns of behavior to emerge.

Student's Chill & Spill work

1 Ebersole & Hess, 1998
2 Hass-Cohen, 2001

An Educator's Companion to Chill & Spill

Art and writing are natural forms of communication for adolescents because often it is easier for youth to express themselves visually rather than verbally.

As students discover gratifying new artistic skills, the image on the page allows them to put their experiences into context, helping them release pent-up emotions and express deep desires and wishes.[3] Additionally, the finished piece of art can serve as a powerful record of personal progress[4] and fill them with sense of pride and accomplishment.

Students learn that they can call upon their own innate talent to communicate their feelings, frustrations, and ideas in a safe and productive manner. This is an especially useful tool for students who aren't able to articulate what's going on inside of them, as emotions that are too deep for words often find a way to surface in their artwork.

Overview of Chill & Spill

Chill & Spill was originally designed to be used by therapists with their clients. However, the activities found in **Chill & Spill** also lend themselves well to classroom use. This **Educator's Companion** serves as a guide for the use of **Chill & Spill** in the classroom. Educators who have not yet utilized expressive arts in their work with students will benefit from this book by gaining knowledge of the concepts behind the pages in **Chill & Spill**.

Chill & Spill is an interactive journal that guides students in an exploration of identity, goals, loss, transitions, and self-awareness through creative self-expression. As the title says, **Chill & Spill** encourages youth to "chill out" and "spill their guts." It is a uniquely effective, eclectic tool that utilizes cognitive behavioral, narrative and art therapies, all of which lie hidden behind the eye-catching and age-appropriate layout and artwork. This guided journal is designed to foster emotional intelligence and teach coping skills that can be sustained

3 Cohn, L. & Chapman, L. (2001). A child trauma treatment intervention: Combing neuroscience, EMDR, and drawings. June 22, 2001, EMDR International Association, TX.

4 Association des art-thérapeutes du Québec, www.aatq.org

into adulthood. The interplay of writing and drawing allows students to "let go," to express and release pent-up emotions. The activities can help youth develop their understanding of their own emotions and behavior, allowing them to choose more effective behaviors.

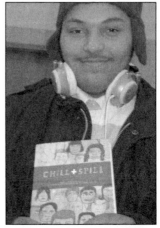

Educators can use **Chill & Spill's** 20 activities as a complete unit, or use it as a springboard to other projects. The journal has clearly laid-out instructions for each activity and is a particularly useful resource for those with limited experience in bringing creative expression into the classroom. Five blank pages follow each activity to allow room for creative expression. A secondary blank book may be used if more room is needed.

Through this companion book, you will learn how to:

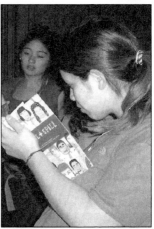

- utilize **Chill & Spill** successfully in the classroom

- coach the creative process

- expand the activities to provide an even richer experience

- talk to students about their artwork

- use various artistic materials

Please note that you don't have to be an art teacher or artist to use **Chill & Spill**. The curriculum makes an excellent addition to health education, psychology, writing, art and life-skills classrooms, as well as advisory periods, and language arts block classes. To become familiar and comfortable with the activities, you are encouraged to work on your own **Chill &**

Students with Chill & Spill

Spill journal from beginning to end so that you too can understand the benefits of self-expression.

Given the power of art to unlock this significant personal exploration, a few students may experience intense emotions. In this case, please consult and collaborate with your school's counseling staff to fully support students who may need extra time and attention. The original **Therapist's Companion** highlights best practices and the therapeutic benefits of the activities for school counselors, social workers and other mental health care professionals. Additional resources are available at **www.artwithheartshop.org**. All proceeds benefit youth in crisis.

The program supports health education, writing, art, and life-skills classrooms

The activities can be extended to support experiential team-building efforts

Goals for the Program

The activities found in **Chill & Spill** are intended to promote:

- Self-acceptance
- Self-expression
- Self-awareness
- Problem solving skills
- Empathy
- Coping strategies
- Relaxation
- Hope & inspiration
- Positive communication skills
- Self-reliance
- Effective decision-making
- Self-care

Chill & Spill benefits students who are facing various challenges:

- Social development
- Low self esteem
- Grief/loss
- Anger management
- Self-harm issues
- Eating disorders
- Substance abuse
- Trauma recovery
- Anxiety/depression
- School crisis
- Family/relationship issues
- Personal/sexual identity
- Bullying
- Serious or chronic illness
- Dating violence
- Emotional/physical/sexual abuse

The process of art-making and creative expression can help youth make sense of their experiences and communicate with others. **Chill & Spill** acts as a catalyst to help deepen students' self-awareness. Each activity provides them with the opportunity to think, write, and talk about the concepts they have explored in the

A student checks out Chill & Spill

chapter through journal writing, artistic expression, discussion, or sharing.

Settings

This curriculum allows students to develop their individual voice in writing and visual art classes and help establish bonding and trust-building in the classroom. It is designed to stand alone as a unit within an academic class or as a complement to existing programs, such as:

- Independent study
- Mentor relationship
- Peer Counseling
- Summer school
- After-school programs
- Leadership development
- Service Learning

Overview of Learning Objectives

Through the use of **Chill & Spill**, students can:

- understand the importance of "chilling" (self-soothing through creativity) and "spilling" (sharing, writing, expressing) their emotions in a healthy and productive way.

- develop creative thinking, perseverance, and appropriate risk-taking.

- build self-awareness and personal identity.

- determine what qualities and core values they would like to exhibit in their lives to become a productive member of community and world.

- Increase active problem-solving by gaining insight into the connection between thoughts, feelings, and behavior.

Grade students on participation rather than the student's artistic techniques or the finished piece.

Alignment with Academic Standards

Many activities in **Chill & Spill** align very well with academic standards used by school districts. The curriculum can be adapted to fit your school's educational goals, learning outcomes or programming priorities, and doing so can increase buy-in from administrators, school boards, and parents.

The activities in **Chill & Spill** have been aligned with the national McRel Benchmarks for the Arts, Health, and Behavioral Studies[5] as well as the Washington State Essential Learning Requirements (EALRs) for the Arts and Communication. A full listing of academic standards and curriculum connections – as well as social skills that can be developed or strengthened through **Chill & Spill** – can be found in Chapter 5 (ADDITIONAL RESOURCES).

The Educator's Role

Your role is fundamentally the same as it is in any of your classroom discussions: listening actively, gently involving and drawing out those who are quiet or hesitant, being positive, caring and understanding, and allowing youth to discover solutions to problems on their own.

The teacher enhances student's experience with Chill & Spill

This book is designed to give you the tools you need to implement this program. In Chapter 2, in the "ENCOURAGING BEHAVIOR & EFFORT" section, you will find tips on how to use praise judiciously in regard to personal artwork. Throughout Chapter 4, you will find open-ended discussion questions that will support each activity and enhance critical thinking. Several terms that we use are included in the GLOSSARY; those words are indicated in an **ALL CAPS AND BOLD FACE TYPE**.

5 http://www.mcrel.org

Various Approaches to Presentation

Art teachers and other educators, school counselors, and social workers are able to use **Chill & Spill** in different ways, depending on the needs of the students they serve. You can use the book as a:

- **Non-threatening introduction** to journaling, poetry, song-writing or creative writing projects

- **Curriculum** for homeroom, creative writing, art class, etc.

- **Extra-curricular programming,** such as creative writing assignments, expressive art projects, journaling club, etc.

- **Incentive** for group participation

- **Tool for building cohesion** among students on teams or in clubs

- **Training tool** for mentors and peer counselors/peer mediators

The "Flow"

The activities in **Chill & Spill** have been created with a specific flow, designed to bring the student on a progressive journey. It follows the natural course of relationship-building – beginning with non-threatening, confidence and trust-building activities. It then leads students through personal exploration of feelings, reactions, and choices. The final activities lead them through closure and goal-setting.

> **IF TIME IS LIMITED**, follow the progression of **Chill & Spill** by selecting activities from the beginning, middle and end. Present the activities in the order they are given in the book, implementing one page per session and targeting activities that are most relevant to your students. However, if a particular activity brings up dynamic discussion, feel free to extend that activity, rather than forcing the pace.

Sample class schedules for 8 and 12-week courses, plus a 14-week art class syllabus can be found in Chapter 5. **Chill & Spill** Educators can also use the Curriculum Grid for an overview of all the activities, including their major themes, a summary of the activity and academic alignments.

Everyone Gets a Copy!

We have stressed how important it is to follow the curriculum in the given order. It is equally important to provide students with their **own** copy of **Chill & Spill** as it provides a private place to express their innermost feelings.

Continuity and trust in the process are lost if students are handed photocopies (copying without permission is prohibited; see copyright information in the front of the **Chill & Spill** book).

Furthermore, the simple act of giving a teen a pristine copy of **Chill & Spill** communicates how important, unique, and special they are. In addition, it is much easier to reference past drawings and entries in order to chart their progress if each student has their own copy of the journal.

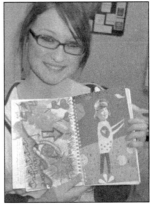

Students learn to trust the process more as they explore their answers in their own book

Age-Appropriate Illustrations

The therapies behind the activities are not apparent to the student. This is deliberate and accomplished through the choice of illustrators who were chosen for their unique ability to relate visually to teens and 'tweens. Students will recognize their artistic styles from television, music, magazines, products and books. The "funky" look makes the activities less threatening and helps students enter the process without hindrance. The art is intended to inspire free-flowing, creative thought as well as to give permission to express themselves in whatever medium and form with which they are comfortable.

The illustrations also provide a secondary usage as inspiration for deeper discussion. Ask students to study the artwork in the book as they go through it and encourage discussions about the meanings or emotions behind each one.

Cultural Relevancy

Cultural norms are often strongly ingrained in a person's daily life and many times they may be unaware of certain behaviors. The activities in Chill & Spill can help raise awareness of both healthy and unhealthy cultural norms and behavior patterns that are typical of specific groups who share the same values, attitudes, beliefs and behaviors. Chill & Spill can inform you of the learning the student has experienced from family, peers, others, and their environment, which will help you be culturally sensitive, and also help with prevention of at-risk behaviors.

By creating a framework of acceptance and personal empowerment, the activities can allow students to search for their identity within their culture and/or peer groups.

Working with Individual Students

Chill & Spill can be used effectively in a one-on-one or independent study setting because it offers a systematic and guided curriculum enhancement that can translate into increased social or academic confidence.

Chill & Spill encourages new skills

You can select specific skills that you want a student to learn and then guide him/her through the appropriate **Chill & Spill** activities (see the ADDITIONAL RESOURCES chapter for listing of skills and benefits of each activity). This can be an effective way to help develop writing skills, emotional intelligence, and social competency.

When used on an individual basis, **Chill & Spill** can become a tool that helps the educator:

- Build rapport, trust and motivation to increase participation in the classroom.

- Conduct an assessment and then match the student with appropriate programs or interventions.

- Help the student achieve behavioral or writing goals, develop special talents or build self-esteem.

- Accommodate a student's learning style, as well as his/her behavioral or emotional needs.

The activities can be used to review existing knowledge, introduce new skills, and integrate new understanding and personal discoveries with current knowledge. Students should be given time to build fluency in this method and be encouraged to apply learning to real-life situations.

Chill & Spill in an After-School Setting

Chill & Spill is also appropriate in an after-school setting. It is an excellent way of meeting the competing demands of providing educational support while providing high-interest, creative enrichment activities that promote school engagement and personal development. Many districts include personal growth and creative thinking as desired outcomes for students, and this curriculum fits well into those ideals.

Many parents and administrators often expect the emphasis in after-school programming to be on homework completion and tutoring. By connecting the exercises to your school's learning goals, a "**Chill & Spill** Journaling Club" can act as an exciting incentive for students who have completed their homework. As many teachers know, incentives can motivate students to become interested in activities that they might not have been interested in initially, and can strengthen their commitment to learning.

Consider collecting survey data from students who participate in your school's art program. If students are missing less school, getting better grades, finishing more homework, or receiving fewer disciplinary referrals, administrators should know about it.

Another way to integrate the **Chill & Spill** program into after-school activities is to create a "Chill & Spill Art Club," where students complete a page from the book each session. Activities can be extended by following suggestions offered in the EXTENSION ACTIVITIES chapter in this book or by inviting local artists to teach specific techniques. You can also create skill-building or special interest clubs, focusing on painting, clay, collage, etc. (TIPS & TRICKS on a variety of media are also included in the EXTENSION ACTIVITIES chapter).

An Educator's Companion to Chill & Spill

CHILL & SPILL
FROM START TO FINISH

Timing

Timing of the activities in your classroom is critical to your success. In order to make the strongest use of your time, have all materials ready and demonstrate confidence as you transition from free-writing in the journals to the hands-on and sharing portions of your time.

There's a balance to keep: omitting too many activities will reduce student learning outcomes, yet rushing through to the next activity when learning has not yet been established, does not yield desired results.

The amount of active and engaged art-making time by students is a strong predictor of their feelings of success.

Keep sufficient materials and supplies available:

- Make certain the physical layout of your room facilitates creativity.

- Have activities planned for students who finish early.

- Elicit student assistance to complete preparation activities.

- Regularly check to see that you have sufficient art supplies such as pens, pencils, and markers readily available and store materials near the area where they are to be used.

- Establish a routine, such as a five-minute free-writing exercise in their Chill & Spill journals, which will begin immediately upon the beginning of class.

- Reinforce that forward momentum is contingent on completing a particular task. For example, say, "When we have finished writing in our Chill & Spill journals, we will begin today's creative activity based on today's page."

- Observe what activities the students are most interested in and build in additional days around those activities.

A timetable is included in Chapter 5 to help guide you through the stages of preparation.

The Art of Chill & Spill

From sculptors to creative writers to graphic designers, there are as many definitions of "art" as there are media and tools for expressing emotions, thoughts and experiences. When Art with Heart refers to the word "art," we are talking about the creative expression of moods, attitudes, beliefs, and personal symbolism, in a structured setting that promotes awareness, insight, and emotional safety.

If you imagine a continuum of artistic creation from very open to very structured, **Chill & Spill** activities are somewhere in the middle. It is more structured than free-drawing in that each activity is purposeful and designed to meet clear therapeutic goals. It is less structured than a craft project in that it is a process of self-discovery rather than a pre-defined product. It is also less structured than arts education in that realism, accuracy, and technical skill are not aspired to. Attempting realistic art can be a frustrating experience for anyone, including those who have had formal art training. Students tend to criticize themselves harshly for falling short of creating what they imagined in their heads.

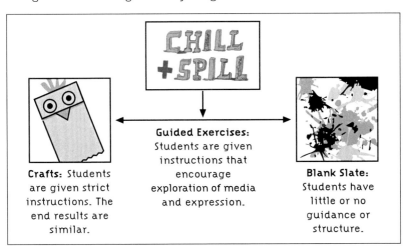

Crafts: Students are given strict instructions. The end results are similar.

Guided Exercises: Students are given instructions that encourage exploration of media and expression.

Blank Slate: Students have little or no guidance or structure.

Students discover their own creative voice most successfully when they are encouraged to break away from what they see in front of them, and learn to express what is hidden inside. The intent of **Chill & Spill** is to encourage self-expression, allowing youth to be unfettered by expectations of perfection, rather focusing on their own unique expression.

To encourage self-expression and account for student's different needs and interests, the activities in **Chill & Spill** can be adapted to any media, including collage, drawing, creative writing, and sculpting. To add excitement to the art-making process, we recommend using materials that invite abstract expression, promote success, and are simply fun to work with, such as wire, collage, and found objects (See TIPS

Students writing in C&S during an assembly

& TRICKS section in the MATERIALS & TECHNIQUES chapter for more information on the suggested media).

Developing a Supportive, Creative Environment

Art can expose vulnerabilities, and so emotional safety becomes an important issue. By fostering traits found in the creative process – curiosity, observation, logic, concentration, discipline and risk-taking – you are creating an environment in which youth are free to grow and share. By modeling and rewarding these qualities, you are helping students feel comfortable as they explore their creativity and discover new artistic methods.

It is important to establish **GROUND RULES** before embarking on the first Chill & Spill project. Creating expressive art is

When possible, offer a creative environment in which to explore the Chill & Spill activities

a more personal endeavor than many typical classroom activities, and students need to be aware that the expectations for in-class behavior, and out-of-class confidentiality are different. In the first session, brainstorm with students what rules they believe are necessary to create an environment that supports open expression. Record these rules, and

An Educator's Companion to Chill & Spill

review them at the start of each session. Sample ground rules include:

- Books are private; no peeking
- Positive feedback only; no criticism
- No phones or texting
- Everyone has a chance to share, no one is required
- What happens in this class stays in this class

Several additional practices can also help create an environment that supports creative expression:

- **Focus on the experience** and process rather than the end product. Refrain from instructing students on a "correct" way to visually communicate an idea and allow them to find their own way. It is not about creating "pretty" pictures or writing and re-writing to perfection. Emphasize things that are going well for your student and the ways they are improving.

- **Be clear** at the start of each activity what students will be asked to share and what will be private. Never require that anyone share their finished product. Model for students how to talk about the experience without showing their piece.

- **Ease into the artistic activity** by allowing students to debrief or "check in" before beginning the session.

- Create a **solid understanding** amongst students about **GROUND RULES**, making sure they know that negative, hurtful criticism of each other's work is not allowed. Create an atmosphere of **respect and trust** by encouraging all ideas.

- Foster each student's **natural curiosity** by providing opportunities to explore, discover and create unusual or interesting things, noting that a hesitant student may crave more familiar items.

- **Offer a variety of media** such as pencils, colored pencils, oil pastels, markers, collage materials (see the next chapter for lists). Remember that age, personality, ability, interest and skill level will influence their choices, processes and end results.

- Give students time to explore and **get comfortable with the media** they are using to increase inspiration and success, providing opportunities that are not based on ability or craftsmanship, but on the opportunity to observe, explore and experiment.

- Focus students' answers on **what makes them unique**. Encourage assertion of ideas rather than reliance on the expected or tradition, encouraging a spirit of play and experimentation.

- **Inform students about transitions** to help ease them from one part of the activity to another.

- **Allow for the possibility** that what students have created is private, and that they may not share it with you. Praise the fact that they've communicated a boundary to you and respect their desire to keep certain things private.

- **Don't assume** that you know why students choose to draw or collage particular images. Even though the art can sometimes give the educator some idea of their concerns and life circumstances, you should encourage storytelling about what they've produced, and accept what is communicated.

Introducing Chill & Spill to Students

The **Chill & Spill** journal gives your students a place where they can feel free to express their innermost feelings. As you pass out the books, let students know that the journal is theirs to keep, and whatever they write and/or draw in their journal is private. Let them know that the journal is as sacred as a diary. This means no peeking by you or others. If students feel that you might look, then they may write, draw or doodle with you in mind, defeating the purpose of uninhibited truth-telling. You can encourage your students to share their journal entries, but accept the boundaries they create.

As the students open up **Chill & Spill** for the first time, point out that you will be leading them through some or all of the guided activities. Ask students to examine the book, beginning with the outside cover. Ask students to:

- Examine the book – exploring the outside cover first. Do any of the faces look familiar to them? What about the expressions?

- Read the quotes found on the inside and back covers. Do any of the quotes have personal meaning? Why do you think the authors put these quotes in here?

- Look at the artwork throughout the book and make observations about them. Do you feel that you can do any of these styles? Why do you think the publisher chose these artists?

- Sign their names in the book with a unique and personal signature.

At the beginning of each class, bring students' attention back to **Chill & Spill** to cement and enhance what they gained from the previous class.

At the end of any art-making activity, we recommend that you hold onto their artwork till the end of the semester or quarter, so you can have a celebratory "art show." Problem-solve with students on how to keep the artwork safe and private.

Showing Sample Artwork

Giving students a sense of the possibilities can be just the right springboard to unlock their creativity. Providing examples of many different types of artwork can encourage students to explore numerous methods of approaching art. It can also open up creative solutions that may not have been readily apparent before. We avoid showing examples of **realistic** art or anything that seems too "perfect" since this does not inspire, but rather intimidates and demoralizes students who may already think that they can't "do art."

In Art with Heart's workshops, we offer examples of work that seems attainable – often focusing on modern, abstract or folk/outsider art, which tends to have a more handcrafted look and emphasizes art as a means for personal expression. These types of examples serve as an opportunity to weave in mini-lessons of art history and art appreciation. In several of the extension activities, we have listed artists whose styles may serve as inspiration. Consult your local library or do an online search to find

Showing examples can help open up creative possibilities

other appropriate examples.

Use the artwork found in **Chill & Spill** as the first example as you introduce each activity. Ask questions such as, "What do you think the artist was feeling when he or she did this piece?" or "What stands out to you on this page? What do you notice?" or "What do you think these details mean?"

If you do the **Chill & Spill** activity ahead of time in your own personal copy (as recommended), you can use **your art** as an example. The idea is not to "show off" your skill, of course, but to engage students' interest in the many different possibilities of interpretation of the assignment. While you show your work, break down your process for the students, showing the steps you took to produce your art. Remember to give yourself the same time limitations that you would give your students to produce your piece.

Show samples of other students' artwork to inspire your class

Many students also respond positively to examples of **other students' artwork**. Ask students who have created work through the class if they are willing to let you show their pieces as an example. After you have shown the examples, put them away before you begin the project so that students aren't tempted to copy or compare their work with the finished pieces.

EFFECTIVE USE OF MODELS AND SAMPLES:

- Choose a variety of styles and levels of expertise
- Folk art/outsider art
- Your own model
- Youth art
- Avoid realistic models or "masterpieces"
- Put it away after you've shown it

Doing The Project Together

When possible, we recommend working on your own piece alongside your students. This gives you a chance to model your own process showing that the project is both important and fulfilling. It also helps to set up a different kind of relationship dynamic – instead of you as the adult who grades their work, you are an artist as well, working side-by-side with them. The sharing time at the end is now enhanced because each of you has had your own experience with the project. To foster complete engagement in each project, allow students to work independently, but remain open to questions and conversations that may arise.

Timing: Creating Smooth Transitions

Consistency helps create group cohesion. If students are aware of the class structure, time limitations and expectations, you will alleviate stress related to unanticipated transitions and maintain emotional safely throughout the class. Clearly describe what will happen during the class, when transitions will take place and what to expect at the end of your time together.

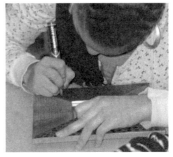

Students often get "lost" in the process

For example, you can announce "First we will work on finding collage images for 10 minutes, then I'll give you a one-minute "heads-up" when it's time to start assembling what we've found." As you are nearing the end of the activity time, it's helpful if you point out "10 minutes left" – "five minutes left" – "one minute left" and "That's it!" It's also helpful to set up how the session will end: "Now we'll use the last ___ minutes to share our work with each other and then clean up and talk about next week's activity."

Students can get engrossed in art-making, making transitions difficult

This can be a difficult moment for some students when they have become particularly engrossed in a project, or if their work style involves a lot of

thinking and planning on the front end and they feel frustrated because they've run out of time. Acknowledge and validate that it is hard to stop something they want to keep doing. Offer to problem-solve with them to help minimize or tolerate their frustration.

Try not to force the pace. Give yourself enough time to adapt to student needs and be flexible within the schedule. Consider extending a particular activity over a series of hours, days or weeks, if you perceive that students wish to continue exploration of the given theme.

Coaching Creativity

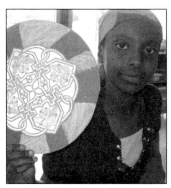

Encouraging creativity in students often demands creativity on your part. Compare your role to that of a coach: a good coach can turn a team around by improving morale, performance and confidence. Coaches help players improve their skill. They focus on future success rather than past failures. A coach doesn't bring the answer to the game – he or she brings a process

Students thrive when given the opportunity to explore

for helping each team member discover his or her own strengths and abilities. They inspire, energize and facilitate the development of each individual player.

You will be coaching the use of art in self-expression, exploration, and discovery – not the development of artistic style and technique. In that spirit, tailor your comments so that you are praising the behaviors that you want to see: risk-taking, perseverance, patience, and self-confidence. Avoid comments that emphasize the importance of the finished product or technical mastery. Also be aware that some words can inspire competition (good, better, best) and some words can instill insecurity or feelings of inadequacy (right, wrong, mistake, easy, hard).

As a coach, another one of your roles is to push your students to be more creative than they realize they can be. Ask "what if" questions, and show them interesting tricks, techniques, and ideas to get the most out of their work. Help them let go of preconceived ideas of what their finished product should look like and encourage exploration.

Validation

How do you encourage students who feel that their artwork isn't "good enough?" What do you do when a student fishes for compliments? How do you react when a student tells you that the activity you worked so hard to prepare is "stupid?" You **validate**.

Validating means accepting your students, even when they're having a hard time, rather than trying to convince them that things aren't so bad. Communicate that you have heard their concerns, that they make sense and are important to you, even if you disagree with them. It sounds simple, but it isn't always easy to do – but when it's done well can have a profound impact on the relationship.

In its most basic form, validating is repeating what you've heard to make sure you've got it right. In his book "The Happiest Toddler on the Block," Harvey Karp uses the "Fast Food Rule" to describe validation. Think about it: when you order fast food at the drive-up, do they tell you how bad it is for you? Or wonder how you could be hungry when you just ate an hour ago? No. The first thing they do is repeat your order. That's what validation is at its core: really listening, then seeing if you've understood what you've heard.

WHAT IS VALIDATING?	WHAT IS INVALIDATING?
Communicating "It makes sense to think/feel that way"	Communicating "you're over-reacting"
Respecting their thoughts and feelings, even if you disagree	Trying to change their mind
Your first response, before problem-solving	Immediate advice-giving or problem-solving
Recognizing out loud the feeling behind the statement	Knee-jerk reassurance ("it's going to be okay")

Encouraging Behavior & Effort

One of the goals of the **Chill & Spill** Program is to teach students to use art for coping with difficult issues, self-expression and self-discovery. As you work with students, be mindful of making comments that support that goal. For instance, as tempting as it may be to lavish praise on your student's finished product, be aware that praise can actually stifle creativity and decrease motivation. To this end, focus your praise on the behavior of creativity, of participating in the process of making art rather than the product itself.

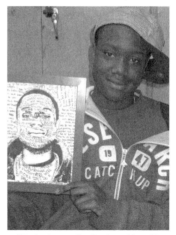

Student proudly displays his self-portrait inspired by Chill & Spill

Avoid statements that create "labels" or further need for approval. Also note that critiquing artwork, even if constructive, can sometimes be unhelpful and defeat the joy and freedom found in self-expression:

- That's pretty (realistic, good, nice)
- You're very artistic (talented, creative, smart)
- Sky is supposed to be blue
- What you really should do is...

When your students get frustrated, or embarrassed that their pieces have turned out to be "messy" or "ugly," it can be tempting to try to convince them that the piece is "good." Instead, remind them that they don't have to like every single drawing or painting that they do, that it's all part of the process, and that the piece can evolve. This can be a good time to share your own experience of the creative process, like how you sometimes hate a piece that you are working on halfway through, or how it's important

By encouraging effort, you encourage exploration

for you to take a break when you get frustrated.

One way to comment is to reinforce perseverance and risk-taking behavior:

- "I am impressed with how you stuck with this project, especially after you said how much you hated painting."

- "I love how your collage uses a wide range of images that express who you are and that you didn't spend a lot of time searching for the one perfect thing."

- "I bet it was hard to stay in class today and work after the day you described at the beginning. I'm so glad you're here."

You can also comment on the art itself in ways that foster independent thought rather than praise-seeking:

- "Tell me about what you did..."
- "Wow... how did you get that texture?"
- "I noticed that you used a lot of (color, shapes)..."
- "I have no idea what that is, but I am totally intrigued!"
- "That _____ really caught my eye."
- "I love seeing you so involved in what you're doing!"
- "I wouldn't have thought of doing that..."

It's crucial to watch the tone of your voice – keep it light, suggesting that you really want to hear the answers to your questions, and you're trying to figure out how to solve the problem together.

Remember: you are there to help them learn things about themselves, including what they tend to do when they get frustrated. In that light, everything they do is useful and meaningful and no moment is a failure.

Some students will work very hard to get you to tell them how good you think their work is. In fact, they may get angry or hurt if you don't tell them how fantastic their art or writing is, especially if others have in the past. In our experience, constant reassurance and praise quickly become bottomless wells that you can never fill, regardless of how many times you tell them how great you think their work is.

Here are examples of responses that you can say to students who fish for compliments:

- "It may sound strange, but art is really all about expressing yourself. There is no right or wrong, or good or bad way to do it."

- "Professional artists have piles of work that didn't turn out the way they were picturing it their head. They may create dozens of versions of a project until they're satisfied with the result."

- "Of course I think it's great, I think everything you do is great, but what does my opinion matter anyway? Your art is for **you**, not for me – or anyone else."

- "I'm tempted to praise every fabulous detail of that piece, but the worst thing in the world would be if you started trying to make things because you think I'll like them. I'm more interested in hearing what **you** like about it."

Bear in mind that students listen carefully when you talk to other students; so praising one while neglecting to make comments on the other will **not** go unnoticed.

Embracing "Mistakes"

It is important to create a risk-taking environment in which mistakes are welcomed. Your students are on an evolutionary journey. If they start in an atmosphere of trust and trustworthiness, they will come to understand that mistakes can be made and that in fact, mistakes are a part of learning.

There's more freedom when you focus on the process instead of the product

There are some misconceptions that students (and adults) may have about creativity – that people are either talented or not, that art has to be realistic, and that mistakes are disasters.

You may notice that some of your students feel like they've made a "wrong turn" in their project and have made a "mistake." It is important to find the healthiest way to help them past this hurdle. Your goal is to help your student recognize and avoid the strong voice of their "Inner Critic" in the future.

An Educator's Companion to Chill & Spill

Again, it can be tempting to disagree with them and tell them how well you think their piece is turning out. But keep in mind that this is a teachable moment: your statement won't change their minds and, worse, it may sound like empty praise.

Instead, help your students resist the allure of perfectionism, since it only brings resistance to risk and inhibits "chance" discoveries – the entire basis of creativity and self-expression. When students judge themselves harshly against these unrealistic standards, their fear of mistakes grows and can constrict and eventually harm imagination, originality, and inventiveness.

Artists understand that mistakes often turn out to be a gift that helps them break away from unattainable expectations and allow them to "go with the flow."

Flexibility in new ways of seeing and the ability to work through mistakes are important elements for their continued creative development. Adaptability allows students to learn from – and even prosper from – mistakes made along the way.

Here are some things to try if you suspect your student is suffering at the hands of their Inner Critic:

Help your student overcome the "inner critic"

- "What's the worst thing that could happen if you didn't listen to that voice inside you saying that you can't do it?"

- "Luckily, this whole process is about trying things out and seeing what happens, not creating the next Mona Lisa."

- "What's something that you know how to do now that you didn't before? How did you get yourself to try it?"

Encourage students to see mistakes as information about what works and what doesn't work; how to approach things in ways they hadn't considered before; and how to open up to new possibilities. Model flexible behavior by pointing out mistakes that you've made and showing them how, even though this wasn't what you were intending to do, it presented you with some new possibilities. Show them through your

actions how you adapt to unexpected situations. You can refer back to the examples you showed in the beginning of the project or an art book you have, showing that there is no "right" or "wrong" way to do art – everyone does things differently.

Also let your student tell you what they feel isn't working and help them see other ways of working around it. Help them let go of preconceived notions by saying something like, "It never works for me when I decide ahead of time how I want it to turn out and then force it." At the same time, validate how frustrating it is when things don't turn out the way you envision them. If they aren't making mistakes, it may be that they aren't stretching themselves enough or learning enough or risking enough.

Talking to Students About their Art

In a "perfect" world, each student would begin every art project with enthusiasm and finish with a masterpiece – with no bumps along the way. However, as mentioned before, the act of making art can bring up anxieties and vulnerabilities in all of us. Artistic skill level, past negative experiences with art, fear of criticism, and numerous other factors can influence a student's openness or resistance to any creative project. This section provides guidance on how to encourage students to create art, how to talk to students about their art, and how to model appropriate boundaries during sharing time.

YOUR STUDENT DOESN'T WANT TO START THE PROJECT

Even if you've completed your planning well ahead of time and are confident that the project will be a big hit, you may find a student who is reluctant to participate. "I don't wanna" or "This is dumb" are phrases you may hear. These statements are often code for things like, "I don't know how to do this," or "I'm afraid I'll mess it up and look dumb." Resistance often stems from lack of confidence or

Reluctance often stems from a lack of confidence.

fear of failure. In many cases, students compare their drawings to professional artists, which leads them to be self-conscious about their own artistic ability.

Hearing this may make you feel frustrated or disappointed, even

embarrassed, and you may want to convince the student that it's a great project they are going to love. The problem with this is that it tends to make them cling onto their state of mind. Instead of invalidating their feelings, use one of these prompts to create a dialog:

- "What makes you not want to do it? Do you not feel like doing art today, or does this particular activity not interest you?"

- "Can you explain what that means? Does that mean that you don't know what I'm asking you to do? Or that you don't feel like doing this? Or that you don't know how to get started?"

- "It could be that you'll hate this, or it could be that you'll love it. Are you willing to give it a shot, and see how it goes?"

Help them risk being "wrong," help them to be willing to put something down on paper without censoring it. By encouraging their efforts in a non-judgmental way and providing positive feedback, you can help them gain confidence in their own ability.

As you know, sometimes as students watch the others have fun, they will eventually join in. If your student still insists on not doing the project, you can keep him/her engaged by asking them to become your assistant during class, or to journal quietly.

YOUR STUDENT CLAIMS THEY "CAN'T DRAW"

When students say, "I can't draw," or " I only draw stick people," what they often mean is "I can't draw what I see in my head."

Artistic ability actually is irrelevant when doing the activities in **Chill & Spill**. Encourage them by saying, "If you can write your name, draw a stick man or scribble, you can do this. It's the meaning behind the drawing that really matters and what you discover about yourself while you do it."

Sometimes your student is having difficulty because they are unfamiliar with the supplies or feel discouraged by their skill level in comparison to other students. Whatever you do, **do not be tempted to draw or paint for them**. Be attentive and supportive. Provide additional tips or tricks on how to use the materials, brushes or tools to give them greater success.

YOUR STUDENT WANTS TO QUIT IN THE MIDDLE OF IT

Sometimes you may hear a student say, "I can't do this! I quit!" It can be tempting to try to talk your student out of this by saying something like, "Don't quit – you're doing a great job!" But the problem is that you haven't really heard what the student is **really** telling you. Listen carefully to find the kernel of truth in their statement. Validate their feelings by replying with something like:

Validate that sometimes the creative process doesn't come easy

- "You feel like quitting, huh? I get to that point sometimes too..."

- "Does that mean it's not turning out like you pictured it in your head?"

- "I can see how frustrated you are. What works to get you less frustrated?"

YOUR STUDENT WANTS TO THROW THEIR ART AWAY

When a student says, "I hate this!" it may be tempting to say, "What are you talking about? I love it!" But our discomfort over their emotional distress actually invalidates their feelings. We get anxious and want them to calm down so things don't get out of hand. But this kind of reassurance can be a double-edged sword – either they think you are lying to them or they think you have terrible taste. Either way, you've lost credibility in their eyes. Instead, try replying with:

- "It's tempting to throw it away when you hate it. Let's take a break and see what you think about it in a little while."

- "You know, I have some extra art supplies you can experiment with if you want... let's take a look."

- "It's only a mistake if there's a right way to do it... and there's not."

If you aren't able to help your student get past this feeling, ask them to give you their artwork for the week. Let them know that even though they don't like it now, it may be useful for a future project like a collage. You can hold onto it for a while and re-approach them with it later, as their opinion might change. You can also use it to show other students – oftentimes others are amazed to see what someone else regarded as garbage.

An Educator's Companion to Chill & Spill

YOUR STUDENT IS "DONE"

Some students may finish their project quicker than expected. Whether this occurs out of competition to be the fastest and the first one finished, or due to lack of interest in the project, there are ways of re-engaging students back into the project. One of our time-tested approaches involves displaying only a small portion of the available art materials at the beginning of class. As students approach different stages of completion, we introduce new supplies, including **ITEMS OF SUSPENSE** leaving the most unusual or interesting for last to allow them to expand their project

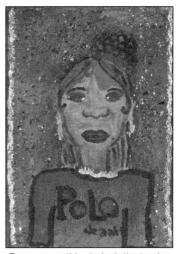

To re-engage this student, the teacher brought out additional supplies such as rickrack and glitter

in unexpected ways. Students often get excited when presented with materials they rarely get to use.

Sharing & Reflection

Sharing is a essential part of ending each **Chill & Spill** exercise, as it becomes the foundation for critical thinking, increased emotional vocabulary, and adaptive coping skills. At the end of the class, students will likely have produced a piece of artwork or creative writing that can be used to facilitate discussion. The act of sharing art teaches students to respect the work they have created. It offers space for deeper reflection, and provides a more purposeful and meaningful session. Sharing can also nurture the development of peer connections – empathy increases as students are exposed to other viewpoints. They will also begin building

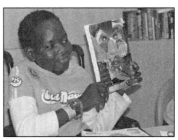

Once safety is established, youth feel free to share the process and sometimes the product

the foundation for critical thinking, increased emotional vocabulary, and stronger coping skills. Be clear in your introduction that everyone will be invited to share, but no one is required.

Some students may not want to talk about the specifics of their art. Ask them to talk instead about what the process was like for them

Getting the most out of discussion time requires some discipline and courage on everyone's part. It may feel difficult to get students to discuss their art, but if you stick with it, they will reap the rewards of increased confidence, verbal self-expression, and insight.

You may wish to create a specific space in which students share their artwork or experience. Suggestions for creating space include:

- Identifying a separate space in the classroom or a different room that students move to when it's time to share

- It could be as simple as drawing chairs into a circle

- One incredibly comfy chair for the student who is sharing

- An area rug and beanbag chairs that students can pull out and arrange when it's time to reflect

- Students choose the music they want to play during sharing time

Be sure to give clear guidelines about what "sharing" means in this context. The main focus is on the process of creation, rather than on the details of their product, or personal information about the circumstances of their lives. Allow about five minutes per person, asking open-ended questions to help draw out reluctant speakers. Minimize superficial answers and prying by prompting meaningful dialog with questions, such as:

- "Was this project easy or hard to do? What made it that way?"

- "While you were working on this project, did you have any thoughts or feelings that you didn't expect?"

- "What was it like to work in this medium?"

- "What did you learn about yourself? What will you take out of here with you today?"

Remind students that they can talk generally about their artwork or writing without showing it to the group, keeping in mind that what they have done may be private and contain potentially sensitive material. Honor their decision for privacy and do not insist on having them show you their work. General comments can sound something like:

- "While I was doing this project, my mind wandered for a while, and then I **noticed** that I really got involved in how the clay felt in my hands, and felt a lot of my tension melt away. I had a rough wcck, but **I found** that I was able to put a lot of my frustration into the project."

- "Even though it didn't turn out like I thought it would, **I like** that doing it **made me feel** more relaxed."

- "When I first started looking through the magazines to find images that represented "Powerful" and "Powerless" to me, I **noticed** that I was drawn to images that were kind of expected. But when I **let go** of what the words literally meant, I started finding images that had a lot more personal meaning to me."

- "I **chose** to paint this in blues because it represents how I felt when I learned about my sister's illness. But I **noticed** that as I continued to paint, it became less about the sadness and more about peace."

Consider, at least early on, being the first to share (if no one else volunteers), so that you can model the kind of comments you'd like to hear. Go clockwise around the room so everyone gets a chance and they can anticipate their turn. Model and encourage being engaged throughout the sharing time, not just when it's your turn.

Model how to share without divulging information that's private

In Chapter 4, "EXTENSION ACTIVITIES," we have included discussion questions, which are a natural segue for students to share what their **Chill & Spill** experience was like and what they learned.

Clean Up Together

Providing a task before students leave can help them prepare to move on to their next class. Bring each class to a close by having students help you put away the art supplies, while talking about next week's class, and thanking them for their participation.

Archive the Experience & the Art

The best way to document the projects inspired by **Chill & Spill** is through digital photography or by scanning. This not only chronicles your student's development, but also lets you share samples with future students. If you obtain student permission, you can also take photos during class of the students while in the process of creating art. This is a wonderful addition to a gallery show if you chose to do one at the end. Send us a digital copy – we'll post selected artwork in the Art with Heart online Gallery (please note that not all submissions will necessarily be posted).

Student Evaluations

In Chapter 5, "ADDITIONAL RESOURCES," we have included an evaluation form that you can photocopy and pass out to all your students. You can do this one of two ways: pass it out on the first day, instructing the students to just fill out the first section (name, age, grade, as well as the "BEFORE" question) and then collect them and save them till the last day, when they will fill out the rest. Or you can pass the evaluations out on the last day of class and have them fill out the entire form at one time.

Once all evaluations have been returned, please send them back to Art with Heart (address provided on the sheet). The return of the evaluations allows us to gauge the impact this program is having. Additionally, this information can benefit you to see what the students are learning and how they responded to it.

The End of the Semester

When your final session arrives, celebrate students' accomplishments! Some ideas include:

- The final art project can be one that the class completes together, creating a piece that sums up the experience.

- If appropriate, review all the pieces the students have made from the beginning, discussing what they remember from past sessions, noticing patterns and progress. Offer feedback and observations on their art, their process, what you've learned from them, etc.

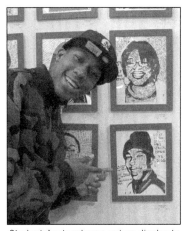

Students' artwork was put on display to help celebrate their accomplishments

- Create an informal gallery show displaying some or all of the pieces. Encourage students to invite friends and family. Create labels with each artist's name and the main goals of the assignment. Students gain self-esteem when their work can be seen by others.

- Combine any of the above ideas, and consider providing pizza, cake, or ice cream or other celebratory foods that make the ending of class special and meaningrul.

Sometimes youth will feel very connected with their artwork and other times, they won't. If they aren't, ask if you can keep the work to show other students at a later date.

SHARE YOUR STUDENTS' WORK WITH US!

Art with Heart often displays student artwork on the website. If the students will allow you to share their art, please have them (or their guardian) sign a media release form (located in the ADDITIONAL RESOURCES chapter), and send it, along with their scanned or photographed images to: P.O. Box 94402, Seattle, WA 98124-6702. Or email it to: info@artwithheart.org.

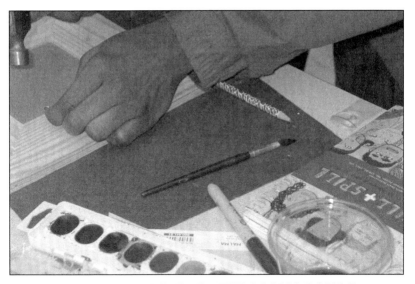

MATERIALS & TECHNIQUES

A Word about Materials

We recommend getting the best materials you can afford because cheaper materials make creating art frustrating and difficult for young artists. When a cheap brush looses its bristles, cheap scissors tear instead of cut, cheap paint cracks and falls off, or cheap paper wrinkles when paint is

Acrylic on a gessoed tee shirt "canvas"

applied, students believe that it's **their** fault, not the fault of substandard tools. Give them every chance to succeed.

Purchase professional grade acrylic paints, artist quality brushes, etc (or ask for donations from art supply stores, graphic design firms or art schools). It will create a richer experience as well as a finished piece that will evoke pride. Look online to compare prices and to check your local home-improvement stores for items such as paintbrushes, clear acrylic finish, varnish, paint, etc. If you have a limited budget, you can still offer a quality experience through **FOUND-OBJECTS** sculpture or **COLLAGE** (the TIPS & TRICKS section in this chapter provides additional details).

Depending on your comfort level and your students' interests, you can concentrate on the media with which you are most familiar. For instance, if you work in ceramics and this medium interests your students, you can agree that this is the medium that you will use for the majority of your sessions. However, students may be curious about exploring a variety of artistic media.

Working in Tandem with an Artist or Writer

There is an opportunity to create a holistic **Chill & Spill** experience by working cooperatively with a professional artist or writer. Professionals can enrich the group experience and introduce new media and skills. Help prepare them for this role by highlighting your ideas in this book and in **Chill & Spill** and brainstorming how their skills might enhance the experience.

Items to Have On Hand

If you plan on doing artistic activities with your students, you will want to have the following materials and supplies on hand.

- **Something to protect desks:** Keep the work surfaces clean by covering them with newspaper, plastic garbage bags, heavy matte board, butcher paper, plastic tarp, or cheap, plastic table cloths.

- **Water**: For collage or painting projects, you will need a source of water. A classroom sink is always helpful, but you can improvise with a tray full of small water-filled containers (e.g. clean yogurt containers, Dixie cups, small plastic bowls, etc.).

- **Color markers**: We recommend that you invest in some fast drying, waterproof ink markers. These markers won't smudge and will allow the student to add paint later if desired. Some markers may bleed through to the next page, so be sure to test them on the paper you intend to use beforehand.

- **Collage materials:** magazines, fabrics, textured materials, baubles, beads, buttons, old jewelry, unusual papers, appropriate magazines, scissors, X-Acto knives and blades (if age-appropriate), circle cutters, hole punches with various punch designs such as squares, stars, hearts (found at scrap-booking stores), fancy edged scissors, and adhesives (see the TIPS & TRICKS section in this chapter for more details on how to use found objects).

- **Paper:** Gather various colors, textures, and weights of paper to provide a plethora of options: tracing paper, brightly colored paper, card stock, scraps of handmade, unusual or wrapping paper, foreign newspapers, canson paper, watercolor paper, and paper you may normally recycle. Typical bond copy paper is useful for drawing and sketching ideas, but does not accept layers of glue or paint well.

The Chill & Spill activities welcome a variety of artistic methods and materials

It is also not archival quality, so the work will eventually disintegrate. Good quality art paper is thicker than regular sketching paper and can withstand various applications. It doesn't buckle and warp when glue is applied, and provides enough tooth (texture) to hold paint. For ink and watercolor projects, it is often cheaper to buy large sheets of watercolor paper than to purchase ready-made pads. For printmaking, purchase paper especially made for this purpose for the best results. We recommend avoiding construction paper, as it tends to fade over time.

- **Heavyweight board**: Often students are offered card stock, poster board, and tag board, but these tend to buckle or warp when you attempt to collage or paint on it. Better alternatives are watercolor paper, Bristol board, illustration board, museum board, or multimedia board – all of which you can find at art supply stores. Illustration and multimedia boards provide a good base for a variety of media because they have few media limitations and are built to withstand many layers of paint. There are two different types from which to choose: Cold Press is a slightly textured surface, which accepts pastel and watercolor well, while Hot Press is a smooth surface for pen and ink or where greater detail is desired. Both are only finished on one side. Bristol board is lighter in weight than illustration board and it provides both a front and back working surface. Additionally, heavyweight recycled boxes can be used as the base for projects if you apply gesso first.

- **Gesso**: This opaque, acrylic substance is used to prime canvas or wood for paint or mixed-media art. It prevents paint from soaking in and gives the surface some thickness and texture so that the paint adheres. It is a useful option for students who would like to collage or paint directly in their **Chill & Spill** journal, as it helps to add strength to the pages. One thin coat on one side of the journal page is often enough to create a surface on which to paint. Always purchase name-brand gesso, since the cheaper gessos tend to have more water, meaning it will take longer to dry (and can wrinkle the page you are applying it to).

A thin coat of gesso will allow students to paint directly inside Chill & Spill

Apply a thin coat directly on the page and allow to dry flat. Once dry, the page is ready to accept collage or paint.

- **Found objects:** Visit your local thrift stores, yard sales, junk drawers, and recycling centers – and even your own garage or junk drawers – as they are often filled with objects that can be useful in art projects. If you want to include the use of wooden objects, check the scrap boxes at lumber mills. Also look

Students used smooth rocks to create self portraits, showing that art can be made with almost any material.

for non-precious costume jewelry, worn-out shoes, buttons, pop caps, doll parts, broken electronic equipment or small appliances (toasters, vacuum cleaners, radios, remote controls), beach glass, cloth, leather, old photographs, empty containers (plastic bottles, crushed soda cans, etc.), measuring tape or wooden rulers, keys, yarn, folded bits of paper, old hard-backed books, charms, game pieces, scrap wood, shells, driftwood, twigs, etc. These can all be used in mixed-media collages, sculptures or unusual canvases.

Avoid anything edible, slimy, wet, toxic, heavy, sharp or otherwise dangerous. A good rule of thumb is to limit the size of the items (nothing bigger than a bread box), as smaller items tend to be easier to work with in the classroom.

Many sculptures require a base to keep them upright. Bases can be made from scrap plywood, drift wood – even cast-off instruments, suitcases, boxes, wooden crates, mint tins, etc. Other items to consider include paper towel rolls, old CDs, cardboard boxes, egg cartons, etc.

Besides glue, items can be fastened with wire, string, rubber bands, screws, string, paper clips, duct tape, twist ties, pipe cleaners, magnets, Velcro, grommets, binder rings, etc. (see the TIPS & TRICKS section in this chapter for details on how to use found objects).

- **Wire**: This remarkably pliant material encourages creativity: it can be braided, coiled, twisted, wrapped, woven, spiraled, and fashioned into a limitless number of shapes, making it a wonderful medium for student experimentation. Any one of the **Chill & Spill** activities

can be translated into three-dimensions through the use of wire. Because the needed tools are simple, wire sculpture can be learned and performed very easily by all skill levels. All you really need is wire of varying thicknesses, work gloves, metal shears or wire cutters, and possibly needle-nose pliers for the thicker, more rigid wires. Soft wire such as copper is the easiest to work with. Computer or telephone wire is especially suitable, as it is soft and comes in a wide range of colors, and – best of all – is **free** from phone companies! Galvanized wire is harder to bend and requires more tools, but makes an excellent base for adding softer wire to. A heavy gauge wire (like 16 or 18) is perfect for a base structure. Small gauge chicken wire or steel mesh can also be used.

Other types of wire to look for include dark annealed wire (also called tie or bailing wire), picture wire (which includes galvanized wire, copper, brass, or aluminum), clothesline wire coated in colored plastic, as well as florist or paddle wire. Also look for armature wire in art stores. The best place to look for these supplies is the hardware store, salvage yards and recycle centers. You will only need one or two pairs of wire cutters per table of students (see the TIPS & TRICKS section in this chapter for more details on how to use wire).

Cut wire to reasonable lengths to avoid whipping and injuring fellow artists. Wear safety goggles to reduce the likelihood of eye injuries. Only allow students who are responsible to handle the wire clippers.

- **Tools:** Bring any tools you might have that could be useful for creative assembly: jewelry making tools, a drill with an assortment of drill bits, pliers, hammers, screwdrivers and screws, scissors, shears to cut tin, matte or X-Acto knives can all come in handy. Review safety rules with students before allowing them to handle sharp objects.

- **Glue**: Using the wrong glue can result in a frustrating or disappointing experience because it can fail to adhere properly, fall apart later, or ruin the project during its application. When choosing a glue, consider the types of surfaces that will be bonded together. Are they non-porous (usually a slick and shiny surface that does not absorb moisture such as glass, metal, plastic, and glossy paper); semi-porous (a surface that does not absorb moisture quickly or evenly, such as coated paper, fabric, foam); or porous (absorbs moisture easily such as most papers, raw woods, plaster, some clay)?

For collage projects using porous surfaces, the glue shouldn't be too thick (globby) or too thin (watery). Add a little water to thin the glue if needed by mixing a small amount of water with the glue or paste in a small container, separate from the original glue container. Too much water in the glue will cause puddles and increases the chance of wrinkling or poor adhesion.

Our favorite glues are Nori Paste, Yes! Paste, and Mod Podge. Acrylic Polymer Matte Medium can also be used. They all can serve as an all-in-one glue, sealer, giving a more finished look. These tacky glues are thicker, stronger, and stickier than white glues. They dry clear and are suitable to use on most porous, semi-porous, and non-porous surfaces. Cement-based adhesives work well on art that is intended to remain outdoors.

There are several types of glue that should be avoided in a classroom for a variety of reasons. School glue (such as Elmer's) will form a medium-strong bond, but cannot hold heavy objects and tends to have a high water content that soaks into the paper, causing it to warp or wrinkle. Glue sticks tend to loose their grip after a period of time. We recommend avoiding rubber cement, contact cement or spray glue because of the toxic fumes. Use hot melt glue guns with caution (a multi-temperature or ultimate glue gun works for a variety of applications), and as with all products, follow the manufacturer's recommendations.

Glue isn't the only option. You can get even more creative by using band-aids (new, of course), grommets, twine, thread, embroidery floss, hemp rope, ribbon, duct tape, masking tape, among other items, etc. to secure peices together. These can add visual interest to the artistic composition.

- **Brushes:** Brushes come in a wide variety of sizes, from large brushes that are perfect for covering a large amount of space, to extra-small detail brushes. Soft-hair brushes are typically used with watercolor or ink. Firmer bristle brushes stand up well to acrylic paint projects. We recommend the use of synthetic hair brushes because they are easier to clean, more durable, and more cost-effective. If a synthetic brush has become misshapen, it can sometimes be returned to its original shape by placing it under hot running water.

Foam brushes are inexpensive and can be used many times if you take care of them immediately after use. They are used in situations that could potentially ruin a more expensive bristle brush, such as applying glue to collage projects. We recommend using a 1/2" to 3/4" acrylic bristle or sponge brush to coat the pieces of collage material evenly.

- **Oil Pastels:** We recommend using oil pastels over chalk pastels, as inhalation of chalk pastel dust can pose serious health problems. If you must use chalk-based pastels, do so with an electronic air purifier and have students wear a face mask. Because chalk pastels are not permanently fixed to the surface of the paper, they smudge easily and must be "fixed" with a fixative spray, which are also toxic. Any aerosol sprays should only be used with proper ventilation.

- **Acrylic paint:** This is a perfect paint medium for students, as it tends to dry quickly, which avoids long delays between layers. Acrylic paints are resistant to water once dry, which means they can be over-painted without disturbing the previous color.

 Supplies to gather when painting with acrylics include recycled aluminum or tin cans to hold water, brushes, plates for mixing colors, rags for spills, and large shirts or aprons to protect clothing, as this paint will leave a permanent stain.

 You don't need to have expensive, primed canvases to make your painting projects successful. Heavy, corrugated cardboard re-used from boxes, as well as plywood or other old unfinished wood can be used as a base for painting with acrylics, once primed with gesso. The gesso will prevent the paint from soaking into these porous materials. These surfaces will be non-archival, but are all readily available and inexpensive. Wood has texture that can add visual interest to the finished painting. Another advantage of using wood or masonite is that you can cut the wood to unusual shapes – just use a saw and some sand paper to smooth out any rough edges.

 Note that many paints and varnishes are toxic and/or flammable and need proper ventilation when used. It is for this reason that we don't recommend using dry pigments and oil-based paints. Also, avoid hand-to-mouth contact while creating art and make sure students don't put either end of the paintbrush in their mouths.

- **Masonite**: This hardboard makes an excellent and affordable canvas and can be found at most art, home-improvement and hardware stores. The surface is both stable and durable and is a favorite with students, as it creates the feeling that the piece is more important and permanent. You can either purchase this ready-made masonite at art stores, or gesso it yourself. Masonite contains tannins that over time will eat away at your painting if you don't prepare it. Lightly sand the smooth side and prime with 3 coats of gesso, allowing it to dry after each coat. This surface will hold glued objects better than a primed cotton canvas, making it ideal for found object projects. Note that both tempered and untempered masonite can be used successfully for painting.

- **Paint pens**: These specialty pens write well on rough surfaces, such as wood, plastic or rough metal surfaces. Using scrap paper, get the paint flowing by pushing the nib of the pen several times consecutively until the paint begins to flow. Look for paint pens that are permanent and light-fast, noting that some contain solvents and should only be used in a well ventilated area. Typical paint markers do not contain large volume of paint and are often expensive as compared to markers, and can dry out if left uncapped.

- **Clean up supplies:** Art is messy, so gather rags, plastic bags, Windex and paper towels, soap and water.

- **Music:** We recommend providing music to help nurture a creative environment and to keep students interested. You can allow participants to bring their own music – it communicates your respect and openness – but keep in mind that it can increase the likelihood of conflict over competing choices. If you choose the music yourself, try selections that support the mood you want in the classroom, or experiment to see if different kinds of music create different results. Alternating from session to session may be a workable compromise.

TIPS & TRICKS: COLLAGE

Successful Collages

Collage is a great medium for
students who aren't comfortable
drawing because it's easy to control,
provides structure, and stimulates the
imagination.

The more choices, the better

The goal behind a **Chill & Spill** collage
is to create a message through the
patterns, color, and images that are selected. Students should have
the **Chill & Spill** activity in mind while they look through magazines
and choose images that stand out to them. Give students a time limit
(five to ten minutes) to prevent them from reading articles and getting
distracted. The time limit will also force them not to edit themselves and
encourage them to just grab things that appeal to them. Remind them
that they are visually representing who they are and that they need to
look for images that are personally symbolic, not literal.

Your choice of magazines is important, too, as
many teens struggle with body or self-esteem
issues. Avoid magazines that emphasize
wealth, fashion, celebrities or perfect bodies.
Supply magazines that help students **reach
further, try harder and get past the expected**.
Pick magazines that they don't normally read
and will have to work harder at to find good
images, such as gardening or architecture
magazines. Select an array of culturally
diverse magazines depicting different
skin-tones, body types and facial features,
which represent your student population. Also

Grab parts from different
sources

have on hand old wrapping paper, newspaper, old paintings, labels from
packages, price tags, or any other paper scraps that you think have
interesting colors, textures or images. Fabric can also be used.

Challenge students not to use "ready-made images' (such as a model's

face) but to **create their own unique images** by finding various parts from different pages to create an artistic statement (lips from one photo, eyebrows cut out from someone else's hair, clothes from wrapping paper or newspaper articles) that will metaphorically reflect their own unique feelings and point of view. You can also pre-cut facial features for them or instruct them to not use lips for lips or hair for hair. Challenge them to look harder for images (i.e. wheels for eyes, wheat fields for hair, the Classified section for a shirt).

Cut out many different images that catch your eye

A thick base to adhere items to is necessary, otherwise the paper or images can warp or wrinkle when the glue is applied (see the previous section for descriptions of base boards).

Once students have collected all the images they want to use, have them wait to glue items down... encourage them to **combine images, stack, and do the unexpected** (turn the cutouts over... there might be something more interesting on the other side!). Remind them that the images can overlap and that they can build faces out of many different facial features from many different images. Have them arrange, rearrange, and play before committing and gluing them down.

Play with the layout before gluing things down.

Ask students to place paper towels underneath the collage to protect the table. Change and turn the towels often so that the surface is clean and the images don't end up sticking to them.

Students can create their own materials

Apply glue to the back of collage image with even strokes, starting the brush at the center of the collage piece and with a sweeping stroke, brush to the outside edges onto a paper towel or another protective piece of paper. This

ensures that the glue coats the entire back of the paper. Most magazines are made of paper, which often wrinkles. By using a paintbrush to coat both sides of the image with good quality paste, wrinkles will be reduced, if not entirely eliminated. Remind students that perfection is not the goal; wrinkles often are part of the final artwork.

Brush a thin layer of glue onto the top of the collage as well to give it a more "finished look." **Remind students not to shut the book**

Flip it around to see what's on the other side

until the page is 100% dry! Once the collage is dried completely, if the paper has curled or warped, place it face down on a heavy, clean cardboard surface and place a large book on top for 24 hours.

You can also have students make their own paper for later use. Ask them to draw, paint, and doodle on good quality art paper, creating abstract art. Then have students "undo" their piece by inserting it into a strip-cut shredder, or by having them physically tear it into long strips. Have students keep these various pieces in an **ART MORGUE**. For homework, ask students to collect additional flat images from their daily

Old hard covered books make a great surface to collage on

lives to add to the **ART MORGUE** for use with later projects. Store each student's artwork in separate, labeled large manila envelopes for the following week.

CHILL & SPILL ACTIVITIES THAT WORK WELL IN COLLAGE
The Best Three Words • Your Place • Fly Away • Me Myself & I • And I Really, Really Feel • Inside of Me • Powerful/Powerless • Bridges

EXAMPLES OF ARTISTS THAT USE COLLAGE: Sabrina Ward Harrison, Candy Jernigan, Eric Carle, Kitty Kilian, Katherine Streeter (one of the artists in **Chill & Spill**), Joan Miro, Hannah Hoch, Joseph Cornell, Louise Nevelson, Henri Matisse, Traci Bautista, Claes Oldenburg, Robert Rauschenberg

TIPS & TRICKS: WIRE

Creative Flexibility

Briefly introduce the work of Alexander Calder as an artist who created sculptural forms by bending, twisting and joining wire into a variety of ways. Compare the artwork to a line drawing that has become a three-dimensional sculpture. Help students begin thinking in three dimensions by giving them each a long piece of dark colored yarn. Instruct them to lay the piece of yarn down on a piece of paper, creating a face or a body. Have them recreate the image by free drawing on another sheet, keeping their marker, pen or pencil on the paper without lifting it. Once they've practiced this new skill, have them begin drawing faces without lifting their marker from the paper – simplifying facial features as much as possible.

Wire self portrait by 16 year old students

Translate this new skill onto wire, using a **Chill & Spill** activity to guide the students' thoughts. Let your students know that a sculpture using one piece of wire will always be stronger than a piece that uses many different attached pieces (attachments often slip out of place).

Encourage the students to explore the materials and use their imagination to create their shapes. Twist a piece of wire around a pencil and slip the pencil out, to show how they can create spirals. Have beads available so they can slide the beads on wherever they want before securing the wire. The beads can be "free floating" or they can twist the wire to make them stay in a certain position.

Wire is an inexpensive medium that students enjoy

Caution must be used when working with wire,

as it can easily scratch and poke. Provide students with safety glasses and work gloves to keep injuries to a minimum. A good rule of thumb is to have students work with foot-long lengths of wire to prevent accidents, as longer wires are harder to control. Supervise students closely to ensure that they handle wire safely.

CHILL & SPILL ACTIVITIES THAT WORK WELL IN WIRE
The Best Three Words • Your Place • Fly Away • How Others See Me • Powerful/Powerless • Bridges

EXAMPLES OF ARTISTS THAT USE WIRE: Deborah Butterfield, Alexander Calder, Elizabeth Berrien, Ivan Lovatt, Steve Lohman, Ron Stattner, Marilyn Puschak, Angela Hook.

An Educator's Companion to Chill & Spill

TIPS & TRICKS: FOUND OBJECTS

Artistic Recycling

Creating art from found or cast-away objects is inexpensive, fun, and good for the environment. This type of art, also known as **ASSEMBLAGE** art, can be applied to a two-dimensional surface or can become a three-dimensional sculpture. Typically, an assemblage does not disguise the original objects used. Instead, it forms a figurative sculpture from the collection of shapes. Often you can recognize the individual components, yet the assembly of the overall piece creates something "new." The themes and concepts discovered in **Chill & Spill** activities can easily be applied to this medium.

Assemblage with bottle caps

For inspiration, bring in samples of a professional artist's work, asking students to talk about what they see: How did the artist use color? How does it make you feel as you look closely at it? What specific objects do you see? How do these objects help shape a particular message? How does the artist unify the eclectic objects into one sculpture?

Re-assembled toy sculpture

Over a period of two weeks or more, ask students to collect various items from their daily experiences and routines, focusing on discarded or non-precious objects. These items can be broken, as they will be put to new use. Materials are limited only by imagination.

Give each student a large paper bag to keep their found objects in. Supplement students' items with items you find in your junk drawers, garage, yard sales, etc., offering a variety of found objects to share. When

it's time to do the project, students will choose objects from their bags and your boxes of "junk."

Help students begin the process by asking them to create **THUMBNAIL SKETCHES** to help them figure out the placement of their objects prior to assembly. Or, they can begin by laying out the objects onto their desks in order to help them visualize how they can represent their concept. A wonderful example of how junk can be turned into art is Joan Miró's sculpture, "In Caress of a Bird", where he assembled an ironing board, a toilet seat, a donkey's hat, a tortoise shell, and two miniature soccer balls to form a unique sculpture. He typically arranged the found objects on his studio floor during the planning phase.

If you are leading an art class, this is an opportunity to go into more depth and discuss artistic concepts such as balance (of textures and placement), line, color, contrast, repetition, shape, focal point, hierarchy, and texture.

Consider the stability of the sculpture: Does it need a base? Does it need reinforcement from an armature to stabilize it? How will items be attached? One way to stabilize the sculpture is to use an armature. A typical armature is made from heavy gauge wire, bent and twisted to form the "skeleton" of the sculpture. It can be covered in chicken wire to form a base onto which objects are attached. Besides strong glue,

Found objects can give new life to things otherwise destined for landfill

consider attaching elements together with wire, string or fiber. Velcro, magnets, wire, rivets or grommets with binder rings are also useful as attachers.

CHILL & SPILL ACTIVITIES THAT WORK WITH FOUND OBJECT ART
Your Place • Fly Away • Me Myself & I • Circle Journey • Inside of Me • Powerful/Powerless • Shoulda Woulda Coulda • Bridges

EXAMPLES OF ARTISTS WHO USE FOUND OBJECTS: Kurt Schwitters, Louise Nevelson, Robert Rauschenberg, Serge Spitzer, Paul Villinski, Gülsün Karamustafa, Joseph Beuys, Joseph Cornell, Man Ray, Michelle Korte Leccia, Marcel Duchamp, Maria Sol Escobar. Also folk/outsider art.

TIPS & TRICKS: POETRY/SONG

Inspiring Free Verse

Encouraging students to create poetry based on a particular **Chill & Spill** activity allows them to explore another creative medium and "paint with words." Creating poetry based on what they have already begun in the journal extends the learning. The subject matter allows them to have a goal for their poem.

Just as Art with Heart encourages free expression through art, we encourage "free verse" poetry – poetry that doesn't necessarily have to rhyme. Searching for the right rhyming words can slow some students down, and often is not as powerful as free verse poetry which more easily conveys true, honest feelings. "No rhyme" poems are important for students whose limited vocabularies affected their ability to express themselves with the creative nuance they would like.

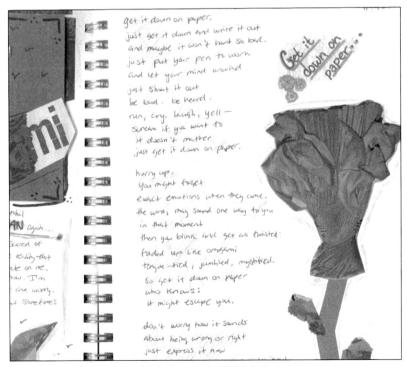

Student poetry in Chill & Spill

USING RAP & HIP HOP TO INSPIRE POETRY IN CHILL & SPILL[6]

Bringing rap and hip hop music into the classroom during a Chill & Spill unit is a popular way of deepening students' understandings of poetry and inspiring journal writing. This cultural medium can invigorate a classroom of resistant writers, allowing students to connect their cultural interests with the curriculum.

By exploring the common elements, themes, and structure in contemporary rap music, students can discover the parallels between the narrative structures of their favorite songs and their own poetry.

Although there are many artists whose lyrics are negative, you can focus on those who promote positive and socially conscience messages, such as Mos Def, Braille, Common, Lupe Fiasco or Talib Kweli; or look for radio-friendly edits of popular songs.

Have students deconstruct and chart out the similarities and differences between the songs, helping them identify the use of metaphor and simile to create imagery for effect. Compare the words of famous poets and rappers, find relationships between the meaning of the words and the rhythm of their rhymes. Pull out similar alliterations, metaphors, and thematic elements. This will help students understand the common elements of poetry in a non-threatening environment and encourage them to create their own expressive poetry based on the activities in Chill & Spill.

1) Using whichever Chill & Spill activity you have chosen, have students do pre-writing, identifying themes that "show up" and are most relevant to them (drawing parallels to the song-writing process and development of ideas).

2) Students will begin to organize words so they rhyme and make sense, and then combine them to create synchronized beats (as a first draft exploration of the lyric's structure).

3) Revise and edit until the song (or poem) seems strong.

4) Ask students who are willing to share their work as a spoken word poem.

6 For futher information, research teachers such as Erin Gruwell (Woodrow Wilson High School, Long Beach, CA), Dawn-Elissa Fischer (Washington Middle School, Springfield, IL), and Alan Sitomer (Lynwood High School, Lynwood, CA) who successfully engaged their students by using hip-hop in the classroom.

"I AM" METAPHOR POETRY [7]

Read examples of poetry before asking students to write their own poems. Good resources include poetry books written by youth and published by WritersCorp: *Tell the World*, and *Paint Me Like I Am*; and poetry books published by Candlewick Press and edited by Betsy Franco: *You Hear Me: Poems Written by Teenage Boys*, *Falling Hard: 100 Love Poems by Teenagers*, and *Things I Have to Tell You: Poems and Writing by Teenage Girls*.

1) In three different columns, brainstorm ideas for the following categories (*examples are shown in serif italic font below*).

WEATHER	ELEMENTS IN NATURE	EMOTIONS
Thunderstorms	*Waterfalls*	*Happy*
Sunny Days	*Earth*	*Jealous*

2) Who are you most like today? For example, do you feel like a thunderstorm? Or maybe you feel like a sunny day?

 Choose one word from one of the columns that you most feel like today. Remember, it's only how you feel **today**. You might be a sunny day tomorrow. Or maybe you'll be fire tomorrow. But for today, which word represents how you feel?

3) Look at the word you've chosen. What are the qualities which go along with that word? Jot down some ideas. For example, thunderstorms: dark clouds, move quickly, across the sky, heavy rain.

4) Write a four line poem. Begin with I am... (insert your weather/ element in nature/or emotion word). Then fill in the other lines with the qualities of the word. For example:

 Fire
 I am fire
 changing the world
 a fiery giant
 Hot, Hot, Hot

7 Poetry unit created by Art with Heart volunteer Mindy Hardwick, who is a writer and educator

PERSONIFICATION EMOTION POETRY[8]

("Powerful/Powerless" and/or "Circle Journey")

Read "Patience" from *The Book of Qualities* by J. Ruth Gendler to the students. The author takes emotions and turns them into small poems using personification. Ask students to fill in the following about either powerless/powerful, fearfulness, anger (or any other emotion).

> Where does this emotion live?
> Who are its friends? *(this could be other emotions)*
> What do they eat?
> Where do they go on vacation?
> What are they scared of?
> What do they love?

Students will then take their answers and turn them into poems about the emotion. For example:

> *Powerless*
>
> *Powerless lives in the wind*
> *Her best friends are fearful and timid*
> *She eats on other's hard luck*
> *Confident that hers is just around the corner*
> *So why try?*
> *Powerless never takes a vacation*
> *She is too afraid*
> *And she'll never love anyone*
> *As that might make her realize*
> *She has Power.*

CHILL & SPILL ACTIVITIES THAT WORK WITH POETRY

Writing & Drawing Can Help • The Best Three Words • Your Place • Fly Away • Exclusive Interview • Me, Myself & I • How Others See Me • And I Really, Really Feel • Inside of Me • Powerful/Powerless • Dream Diary • Shoulda Woulda Coulda • Bridges

8 Ibid.

An Educator's Companion to Chill & Spill

EXTENSION ACTIVITIES

Extending the Activities

Each **Chill & Spill** activity can be expanded upon in order to deepen the students' learning experience. In this section, you will find ideas on how this can be accomplished through artistic activities, along with supportive questions and discussion points to help elicit responses and create a healthy dialog with your students.

Chill & Spill can be extended to projects outside the book

Follow the flow of the book in its given order – even if you don't have time to do every single activity, choose pages from the beginning, middle and end sections that are most salient to your students.

For each activity, be sure that students have their **Chill & Spill** books and a writing instrument, along with basic art supplies. Specialty items and supplies are listed as needed.

Oftentimes, students may need you to allow them to write freely about the subject before embarking upon expressing themselves visually. In this case, visualization activities (such as the one described for "Your Place") will help break down the process for them.

Please note that any times mentioned in this chapter assume that you have 60 minutes for the entire class. Please adjust according to your actual schedule.

In several sections, different artists are named to help you find samples of different artistic styles. Information about them should be readily available online or in the library.

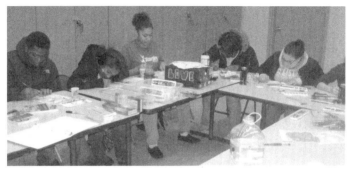

Teens engaged in a Chill & Spill class

An Educator's Companion to Chill & Spill

Chill & Spill Page by Page

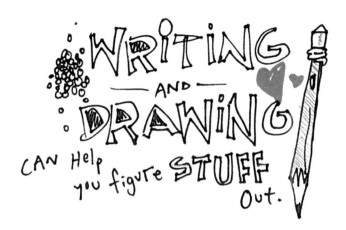

LEARNING GOALS

- Create a sense of ownership of the book
- Engage in relationship-building with the educator
- Promote free-flowing thought
- Initiate conversation
- Establish trust

INTRODUCTION

Hand out **Chill & Spill** journals to each student. Introduce **Chill & Spill** as the "textbook" for the class or group. Ask students to study the cover and see if they "recognize" anyone, or how many different emotions they see represented there. Have students write their names on the inside cover and date it. Discuss the concept of art journals – what they are and the benefits. Open the book to the inside front and back covers. Have students read the quotes and mentally note which ones have personal meaning to them. Next, have students help set **GROUND RULES** for class (see Chapter 2: "CHILL & SPILL FROM START TO FINISH," page 17).

Educators may opt to introduce the activities in **Chill & Spill** with a video clip from the Oregon Public Television (OPB) Series, Lesson 10: Dramatic Art as a Healing Mechanism (www.opb.org/education/atschool/lesson. php?rowid=10). The clip features Rick Bartow, who candidly discusses how his art and music draw from his personal struggles with alcoholism

and post-traumatic stress disorder.

Have a student read the WRITING & DRAWING activity in Chill & Spill out loud. Then give them five minutes for **FREE ASSOCIATION** and to scribble/doodle/write anything they want to. Move onto an extension activity of your choice, keeping in mind your time limits.

EXTENSION ACTIVITIES

Free-writing can help students generate new ideas

- Give students writing prompts, asking them to write lists of their favorite color, food, sport, hobby, smell, magazine, movie, shoes, book, class, joke, etc. Have students share with each other.

- Lead students through a **FREE-WRITING** activity, giving them prompts to help them begin the "letting go" process in their **Chill & Spill** journal. Ask students to consider what they want to do in their lives – where they would like to travel, what they want to learn, try, or explore – and what would it be like/feel like when they do those things. Additional topics include "At dinner last night...", "The most important thing for me to remember is...", "Sometimes I feel...", "If I could... I would....", "When I'm an adult...". You can extend this activity to create collages as well. (SUPPLIES: items for collage)

- Ask students to choose a quote from the front or back cover of the book and write it down on the blank page, following it with what that quote means to them and how it makes them feel.

- Ask them to doodle their initials, creating their own personal symbol.

- Provide research material for ethnic and cultural symbols and ask students to identify symbols of their ancestors that are relevant to their lives. Ask them to recreate those marks in their books.

- Is there a quote, lyric, poem, or word that is on their mind lately? Have students write it in the middle of the page and "decorate" it, using color to show the mood it puts them in.

An Educator's Companion to Chill & Spill

- Write these words on the board: Feelings • Thoughts • Wishes • Goals. Discuss the differences between each. Have students dedicate a blank page to each word and write about each one.

- Have students list all the emotions they can think of. Write each one on the board. Discuss which emotions they like, which ones they hate, and why they think we have both kinds.

- Ask students to write down ten things that delight them – concentrating on the small joys in their lives (for instance chocolate pudding in the cafeteria, or a ladybug on their windowsill). Ask them to chose one and write freely about it for 5 minutes without putting down their pen/pencil.

FOR DISCUSSION

Q: How is an art journal different from a diary?

Q: How can journaling, drawing or doodling be beneficial? Can you see how it can help you purge, release and reflect? Discuss the benefits of saving internal narrative, and having reliable accounts of events in your life.

Q: How can a journal help you with goal setting, breaking bad habits, or changing behavior?

Q: Why is finding a way to express emotions important?

Q: What is "emotional intelligence?" What happens when we understand our emotions? What happens when we don't?

The Best Three Words to Describe Me

LEARNING GOALS

- Build identity, raise self-esteem
- Encourage goal setting
- Allows educator to join in exploring what's important to the student
- Establish rapport with the student

INTRODUCTION

Review **GROUND RULES**. Ask students to fill out the activity individually. Ask what the experience was like for them (see Discussion Questions). Point out the artwork along the margins of this page, showing that each one is a **THUMBNAIL SKETCH** of words that can be used to describe a person's interests or values. When the sketches are used together, they create a short story of a person's life. Review the work of pop artist Keith Haring, studying his use of symbols and bold, direct lines.

EXTENSION ACTIVITIES

- Use what the students wrote in their **Chill & Spill** journal as a starting point. On the left side of the page, ask students to number 1-10 down the page (leaving plenty of room in between each) and then list 10 nouns (person, place or thing) that are an important part of their everyday life. Introduce the concept of metaphors and symbols. Then, next to each of their words, ask them to draw 2-3 **THUMBNAIL SKETCHES** of what each of the words could look like. Choosing the most powerful thumbnail or idea, form a personal symbol or logo that focuses on ideas that are meaningful and representative of who they are and what's important in their lives. This is an excellent activity to expand into a printmaking art class.

Student turns traits and interests into personal symbols

- Use the border illustrations in **Chill & Spill** to inspire them to create a rebus (a riddle or story made up largely of pictures of objects) about an important part of their life (you can help them focus by giving them prompts such as "The funniest thing that ever happened to me" or "Something that changed my life").

- Create a visual "short story" of their life with as many squares as they need. They can explore the symbols directly in their journal, and transfer them onto a canvas – choosing their top three or four images – for a longer activity.

- Ask students to write a Top Ten list of things they are good at or things they want to accomplish over the next year; then illustrate what they look like doing their favorite activity.

- Write these word pairs on the board: Talented/Diva, Confident/Arrogant, Shy/Thoughtful. Do these words mean the same thing? Or not? What are the differences?

- Without naming anyone, ask students to call out words that describe people they like, admire or respect. Then have them call out words that describe people they do not like, admire or respect. Write the two sets of words on the board; discuss the power of the words and value/character traits.

- **Charmed**: Use the logo, rebus or personal symbol they created to make a charm or pin from Shrink Plastic. Follow the manufacturer's instructions and use a hole punch before shrinking the plastic so they can create key chains or charms (SUPPLIES: shrinkable plastic sheets available at craft stores, hole punch).

FOR DISCUSSION

Q: Was it easy or hard to come up with the descriptive words?

Q: Are the words you chose helpful or hurtful? Do they reflect the way you see yourself or the way you think others see you?

Q: What was it like to write about things you are good at? Did you find yourself second-guessing or minimizing your talents and skills?

Q: What does "identity" or "sense of identity" mean? What's important about it?

- Discuss constructive and destructive character traits and values.

YOUR PLACE

LEARNING GOALS

- Establish a real or imaginary "safe place" to revisit as needed
- Help access imagination and encourage self-awareness

INTRODUCTION

Review **GROUND RULES**. Ask someone to read this **Chill & Spill** activity aloud. Ask what they notice about the illustration. Lead them through this **VISUALIZATION** to help them see what their safe place looks like:

I'm going to help you imagine a place you like to be. It may be a real place, or a place that just exists in your head.

First, get comfortable. Maybe put your head down and close your eyes. Listen to your breath. Just notice your heartbeat and your breathing in and out.

Scan your body for any tightness and try to relax those muscles by tensing them for 10 seconds, then releasing (long pause)...

Once your body feels relaxed, picture your favorite place in your mind... a place that makes you happy and calm. It's a safe place, a place where you can fully be yourself and all your worries disappear.

Take a slow look around in this place and take it all in. What do you see around you? Look carefully for as many details as you can.

What do you hear? Do you hear music? What kind? What else do you hear? Listen for a bit and soak it in.

Now find somewhere comfortable to sit. What does it feel like? Is it cozy? soft? warm? smooth?

As you sit there, what can you smell? Take a deep breath and breathe it in. Are you alone or is someone with you? Who would you like to have with you here?

I'm going to be quiet for a moment while you enjoy your favorite place (after a minute or two, say...)

Okay, it's time to come back. Take your time opening your eyes and adjusting to the light in the room...

An Educator's Companion to Chill & Spill

This visualization will enable students to make the leap to any of the extension activities listed below. Allow five minutes to write about what they just experienced in their **Chill & Spill** journal: what they saw, felt, and heard. Ask them to circle anything that struck them as surprising or interesting.

Refer to the art in Chill & Spill and point out that their place doesn't have to be a house

EXTENSION ACTIVITIES

- Ask students to create an inventory of items that are found in their safe place and write about why those items are special.

- Ask students to doodle what their favorite place feels like – without using words or literal symbols, only using colors and shapes.

- From their visualization exercise, have students create **THUMBNAIL SKETCHES** of the three most important things about their safe place. Provide collage materials to help them illustrate one of those concepts.

- Have students draw a floor plan or a map of the area surrounding their safe place (similar to a treasure map). Ask them to talk about their journey to get there: what they feel/experience along the way.

The artist realized that his safe place was with his family and so used an image of a hand to represent them. The "leaves" became their watchful eyes and the "hand" became a tree with deep roots that kept him grounded.

- Have students create a three-dimensional rendition of their safe place using found objects. You can also use old drawers whose dressers are long gone, cigar boxes to create a sculpture or 3-D layout inside (SUPPLIES: See the TIPS & TRICKS: FOUND OBJECTS section, page 55).

- Ask students to help you create a "safe place" in the classroom. What are some different locations? What things should be in the safe place? Comfy chairs? Xbox, Wii or other games? Snacks?

- **Fabric Assemblage:** Use masonite as the backing, have students do an outline sketch of what their safe place looks like with pencil, laying down a rough idea of what it will look like. Instruct them not to get too detailed (note: the pencil lines will be glued over and won't be seen). Using a piece of tracing paper, trace over the design and use the paper as a pattern to help them cut fabric pieces out. Ask students to choose a color scheme and choose scrap fabrics in those colors. As they cut the fabric out, have them lay them out on the board. Once final decisions have been made glue everything down, smoothing it all out and making sure everything is adhered firmly. Use rope, jute or yarn to outline the design. Once everything is dried, glue a picture hanger to the back. (SUPPLIES: fabric, masonite, scissors, craft glue, and rope, jute or yarn)

FOR DISCUSSION

Q: Where can you feel quiet and safe in your life? Where can you just "be you?" Where do you go to help yourself think?

Q: In the "safe place" you made up in your mind, how can you get yourself to be "grounded" enough to go there?

Q: What songs help you feel this way – in your own space, totally happy?

Q: If you could invent the perfect place for you to hang out, what would it look like? When would you go there? What would be there? Who would be allowed to enter?

Q: What kinds of places have you been to that make you feel safe? What is it about that space that makes it feel that way? What makes it different from other places? How can we take those things and make a real safe place for ourselves?

Q: What's beneficial about having a safe place? How can you use your imagined safe place when you need a break from your life?

Q: Why is self-care important? How does that relate to having a place all your own?

LEARNING GOALS

- Establish a "safe place" (extension of last activity)
- Explore the association between nature and feelings, and how we adapt to change
- Build strength, imagination, creativity and story-telling skills
- Build empathy

INTRODUCTION

Review **GROUND RULES**. Have students re-read what they wrote the week before. Read this week's activity. Give them five minutes to brainstorm about the questions posed there and write their answers in **Chill & Spill**.

EXTENSION ACTIVITIES

- Students identify their own support group, and identify what roles each person would take in their growth and nurturing. Have them add pictures of their support system in their drawing or write a poem about it (SUPPLIES: ask students to bring in photographs of their support system; have a copy machine available if students don't want to or aren't allowed to cut up their photos).

- Ask students to imagine they are sunflower seeds needing a place to grow. What would happen if they land in Siberia or Death Valley?

- Have students build a found object sculpture or three-dimensional collage using imagery they created the week before during YOUR PLACE to tell a story about growth. Show slides or book examples of shrine box assemblages to inspire them with the possibilities.

- Provide soil, pots and easy to grow seeds. Have students paint or collage the pots with words and images that represent nurturing to them. Remind them about what happens if the seeds don't get enough (or get too much) water or sun. (SUPPLIES: nasturtium, radish, bean or pea seeds, sterile seed-starting or potting soil, terracotta pots with drainage holes, paint pens or collage materials).

While doing this activity, this student realized that not everyone was "against him' and that he did have a support system around him

- Review different types of trees that are common to your area and ask students to decide what type they are. Have them relate their life experiences to the growth of the tree through the seasons through an essay or poem.

- **Group Collage**: Providing one large illustration board (or thick cardboard cut from a used appliance box), draw a rough pencil outline of a tree and ask all students to add collage elements to it. The rule is that they must choose images that are NOT literal leaves, branches, etc. – for instance, leaves could be from a photo of a green shirt they cut out in the shape of a leaf; branches could be made from images of arms they find in magazines; roots can be made from yarn or rope, etc. Each student adds to the group collage, adding his/her pieces to what is already there.

FOR DISCUSSION

Q: How do you take care of yourself? Do you make time to do that?

Q: How can change make us grow? Why is change painful sometimes?

- Discuss how personal growth can be compared to the way trees grow (in protective circles around the center; even though they have changed, at the very core, they are still the same).

- How is art-making with others different from working on your own?

Exclusive Interview

LEARNING GOALS

- Build identity and self-esteem
- Help manifest a desired reality
- Build confidence in communicating desires
- Increase interpersonal, social and assertiveness skills

INTRODUCTION

Review **GROUND RULES**. Read this week's activity. Allow students five minutes to write in their **Chill & Spill** journal and answer the questions posed there. Have students draw at least one illustration for their article. At the end of class, assign <u>HOMEWORK</u>: ask them to use the questions in the activity to interview those in their support structure.

EXTENSION ACTIVITIES

- Add interview questions to the activity that are relevant to your students. Have them explore the questions in their journals before discussing their answers with the group.

- Expand the interview to include their career possibilities.

- You will need to gather or take photos of each of the students and prepare for this project ahead of time by creating high-contrast enlargements of their pictures. Review the art of Howard Finster, focusing on work that integrates hand-written stories and expressive narratives (the internet offers many examples, or visit the library to find books on his artwork).

This student used a high contrast photo of himself to write his story.

Using the story they wrote the week before, transfer the most important parts of their story (or certain key words) to their portrait to cover it. This will be the basis of a personal narrative that they will

write, all over their pictures. Encourage them to add any additional stories or information to the portrait so that it tells a complete story of their lives.

More advanced art students may alternatively use this activity as a chance to create a self-portrait in paint, using tones of one color (black), writing in waterproof color markers or paint pen once the portrait is dry. (SUPPLIES: high-contrast black and white copies on Bristol board or other quality paper, black waterproof thin-tipped pen, biography of Howard Finster from the library)

Students love this project, as it is all about THEM

- Have students take photos and interview each other, to create an "exclusive" interview for their favorite magazine.

- Read interviews of people who experienced difficult childhoods who became successful, pointing out what might have affected their outcome (examples: actor and survivor of the Khmer Rouge – Dr. Haing S. Ngor, German composer Johannes Brahms, musician Carlos Santana, talk show host Oprah Winfrey, Dr. Wayne Dyer, singer Mary J. Blige, actors Rosie Perez and Eddie Murphy, Dave Thomas of Wendy's, author Maya Angelou, Malcolm X, Holocaust survivors Elie Wiesel and Roman Polanski, etc.).

FOR DISCUSSION

Q: What can you do to make a difference in the world? In your neighborhood? Do you have the power to do that? Why/why not?

Q: How easy or hard is it for you to approach new people? How easy or hard is it for you to step out of your comfort zone? How do you talk to people you don't know very well?

Q: What's the difference between dependence, independence and interdependence? What are the benefits of each? What happens when something is out of balance?

Me, Myself and I

LEARNING GOALS

- Explore identity, including unique feelings, experiences and perspectives

INTRODUCTION

Review **GROUND RULES**. Read this week's activity. Give the students five minutes to write in their **Chill & Spill** and answer these questions: What do you want to be when you are an adult? What is your favorite memory? Have them decide which one they want to explore in their collage.

Introduce collage concepts to students by showing a variety of examples (see the **GLOSSARY** for ideas of artists to research or do an image search online). Give students a tight time line (5-7 minutes) to select and rip out magazine images that represent their answers. Then have them sit down and start cutting images out. Instruct them not to start gluing until they've had a chance to "play" with the composition. They will need a background image to begin from. Rules: they are not allowed to use someone else's face in tact... faces need to be constructed from a variety of sources (for example: the nose is from a model in an ad, one of the eyes is from a wheel of a car, the other is from a cat, the hair is created from a photo of sand). (See TIPS & TRICKS: COLLAGE, page 50, for more details or ideas)

At the end of class, assign HOMEWORK: ask students to do the "How Others See Me" activity (all three panels) and to choose one they are willing to share and recreate as an abstract portrait, using bold lines to represent feelings. This will be for your eyes only.

EXTENSION ACTIVITIES

- Create a "comic book collage" where students explore their past, present and future. Instruct them to fill three squares (5"x5" or larger) with scenes that depict:

 1. A positive childhood memory

2. What makes them who they are today
3. The future that they want for themselves

Students will write a free response in their journal noticing how past childhood experiences might have shaped who they are today, what personality traits they developed as a result, and how those traits can help shape their future. (SUPPLIES: three 5"x5" Bristol board squares, waterproof markers in black and assorted other colors, both thick and thin tipped.)

- Introduce the concept of expressive line to students. Show examples of artists who use line and color to express emotion (jagged vs. wavy, bold vs. pale) rather than facial expressions and body postures. Compare the works of famous artists Vincent Van Gogh, Henri Matisse and Wassily Kandinsky. You can also refer to other artists such as Kazimir Malevich, Barbara Hepworth, Cy Twombly, Jacob Lawrence, and Romare Beardon, for example. Discuss how distilling things down to the essence of an object or idea creates an abstract image that is not necessarily literal or figurative, and how color choices and expressive line can convey emotion. Ask students to practice, selecting a positive memory from their past and illustrating it in expressive line.

- Create a "family crest" (can also be their support group or family of choice) that represents personal identity, cultural heritage, ethnicity and supportive relationships. (SUPPLIES: illustration board or other board that is stiff and can accept paint, acrylic paint supplies, rags)

- Students trace their hand or hands on a piece of cardboard. Cut out the tracing and have them explore, through collage, the theme of identity focusing on a personal goal (trimming all added objects to the hand's outline). On the other side, on each finger, have students write five goals they would like to accomplish in the next five years. Collect student

Hands can be very expressive and can take on many meanings

collages and create a decorative border or mandala along the wall or on a bulletin board. (SUPPLIES: Cardboard, scissors, gesso, acrylic paint supplies, waterproof markers, rags)

An Educator's Companion to Chill & Spill

- Tie this activity in with cultural traditions, such as the seven principals of Kwanzaa: Unity, Self-Determination, Collective Work and Responsibility, Cooperative Economics, Purpose, Creativity, and Faith. Have students research traditions in their own family of origin and integrate those symbols into their collage or writing.

- Find square boxes at a gift or craft store or purchase plain square wooden blocks. Students will paint self-portraits (head/neck only) on each side of the blocks to represent their different moods. Once dried, assemble all the blocks together to form a class mood sculpture. (SUPPLIES: Square boxes, acrylic paint supplies, rags)

FOR DISCUSSION

Q: What symbols represent you? Why? What other symbols or themes show up in your collage that represent what you like, your history, goals or priorities?

Q: How do you place yourself in relationship to your actual or chosen family? Discuss identification.

Q: What steps can you take today to make your future goals and aspirations happen.

Q: Can you point to any traits that you have today that will help you get to where you want to go? Or can you identify any traits that you want to gain that can help you get to your goals?

- If leading the family crest activity, ask how they feel they "fit" into the world and how cultural heritage, ethnicity, supportive relationships and personal identity (including sexual identity) help shape their opinion of themselves.

OTHERS SEE ME
I SEE MYSELF
I WANT TO BE SEEN

LEARNING GOALS

- Increase self-awareness
- Create reflective distance
- Identify traps that block positive connection to others

INTRODUCTION

NOTE: The tri-fold pages for this activity were specifically designed to provide privacy for a potentially sensitive topic. Review **GROUND RULES**. Before drawing in their journals, ask students to write an essay on each of these headlines.

Extension Activities

- Have students review the last journal entry and collage from "Me, Myself and I." Ask them to highlight traits that help describe the way they want to be seen. Pass out the supplies, asking each student to write words that stand out to them on the tee shirt, decorating each to have visual meaning. (SUPPLIES: white tee shirts, fabric markers, cardboard to sandwich in between the front and the back of the shirt to prevent marker bleed through)

- Explore the issues of body image and confidence by drawing:

 1. What Others Want Me To Be (looks, fashion, attitudes, etc.)
 2. Who I Really Am (attitudes, beliefs, strengths, likes/dislikes, etc.)

- Each student gets a shoebox to collage: the outside will represent "How Others See Me." The inside will be a collage of "How I See Myself." Have them place objects and letters they write to their future selves inside ("How I Want to Be Seen"). (SUPPLIES: sturdy box of some sort, items for collage)

- Students look for images that represent how society puts pressure on youth to look or act a certain way. As a class, glue all images on a large poster board, leaving room for a title. Discuss what the title for this piece should be (lies, pressure, media influence, etc.). (SUPPLIES: items for collage, heavyweight board)

- Tie-in to art history: Show Pablo Picasso's self-portrait. Discuss how the artist may have viewed himself as depicted in the self-portrait. Students will begin to recognize the difference between how society (or outsiders) views identity in another person and how they can view their own identity. Consider other famous artists as well, such as Francis Bacon, Frida Kahlo, or Salvador Dali.

FOR DISCUSSION

Q: Why is there a difference between the three images from the journal assignment? How does self-talk influence your opinion of yourself? How does this affect your ability and/or confidence?

Q: How do you decide what to keep private and what to share with others? What's the difference between the two? What might happen if the "inside stuff" became "outside stuff?"

Q: How do you keep your feelings safe? How do you determine whom to trust? Do you trust yourself? Discuss showing "faults," healthy boundaries and vulnerability.

Q: Do you feel that you have to look or be a certain way to be accepted? Explore the theme of societal (media) and peer pressures and other outside pressures. Discuss how identity is perceived from another person's perspective (an outsider's view) and how perception of identity changes depending on one's place in society.

- Discuss how identity is perceived within the pressures of society. Students will also consider how representations of self vary throughout their lives. Students should also be asked to consider how representations of self might change as they get older, depending on their circumstances, activities, jobs, relationships, etc.

- Discuss the continuum of telling all your innermost thoughts and feelings on one extreme, and keeping everything to yourself on the other. What are the pros and cons of each of the extremes? Where on the continuum do you usually fall?

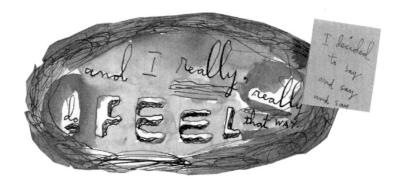

LEARNING GOALS

- Unearth undiscovered feelings, desires and dreams via free association
- Increase self-awareness

INTRODUCTION

Review **GROUND RULES**. Open up **Chill & Spill** books to this page and lead students through free association exercise, calling out the various prompts, allowing 2 minutes for each phrase "I want... I need... I love..." etc. At the end, have them re-read their work and highlight words or phrases that stand out to them.

EXTENSION ACTIVITIES

- After doing the activity from the book, ask students to circle three words that stand out to them and use them in a personal poem.

- Introduce concepts of **TYPOGRAPHY**, showing examples of highly-stylized letters. Show examples from magazines and books as inspiration: illuminated manuscripts, wild-style graffiti, type catalogs, etc. Supply as much reference material as you can. Have students choose key words from their writing exercise and interpret what their words mean – emphasizing color, shape. It is fine to let them hand-copy a letter style or font they like that they feel represents their message best. (<u>SUPPLIES</u>: smooth card stock, pencils, erasers,

Letter stencils over watercolor washes create visual interest

waterproof pens of varying thicknesses, rulers, paint, masking tape, scissors, oil pastels, typographic examples from graphic design magazines or type house catalogs – especially snowboard, music and culture magazines)

- Introduce students to mask-making. Show examples of tribal masks, theatrical masks, and others. Have students research and reflect on the history and meanings of masks throughout history. Discuss how masks were worn both to hide the identity of the wearer and to create another identity. Have students create a mask depicting a concept that they discovered

Student's mask represents the two main emotions he tends to feel

from one of the prompts to encourage deeper self-expression and emotional awareness. The mask can either be a ready-made one from a craft store, or can be created from scratch from recycled and found materials (think outside the box: old mops, raffia, feathers or paintbrushes can serve as hair, old bicycle seats serve as the base for the face, eyes can be made from anything round). (SUPPLIES: ready-made masks or create one from found objects which will be adhered to a cardboard base, glue, items for collage, acrylic paint supplies, oil pastels, scissors, hole punch, rubber bands or elastic, additional materials such as yarn, felt, beads, feathers, etc.)

- Lead the activity by calling out the prompts, allowing 3-5 minutes in between each one. Ask students to share one sentence from what they wrote that has personal meaning and discuss it as a group.

FOR DISCUSSION

Q: How do you normally get your feelings out? How does it make you feel – better or worse? How does this affect others?

Q: Are there feelings that you can have and not share? What is it like when others' share their feelings with you?

- Discuss the expression of feelings within a safe relationship.

- Explore how people can expand their emotional vocabulary and what happens when you are able to name an emotion (the intensity goes down).

Circle Journey
Mandala: Part 1

LEARNING GOALS
- Explore themes of self-discovery, change, rebirth and renewal
- Encourage students to reflect on the natural cycles of life

INTRODUCTION
NOTE: Part 1 of this activity involves the coloring of the mandala example in the Chill & Spill book as a warm-up exercise and an introduction to mandalas.

Review **GROUND RULES**. Open up **Chill & Spill** and ask students to observe the mandala found there before they color it. Color in the mandala inside with waterproof color markers. It is best if students work quietly so that each person can concentrate on their own experience. You can play soft music to help set the mood.

EXTENSION ACTIVITIES
- Introduce the concept of mandalas in art history, showing examples from nature, science and architecture (many can be found online).

A mandala can represent different areas of life

- Talk about balance in nature and how this mandala represents the elements of nature and man.

- Show students examples of mandalas. Identify common symbols, shapes, composition, and form prevalent in many mandalas. Brainstorm symbols that students can use in their own mandalas that would represent them.

- Find mandala templates from your local library for distribution to the students and have them color those as well. Cut each one out and display them together in the classroom.

An Educator's Companion to Chill & Spill

FOR DISCUSSION

- Define mandalas: The word is Sanskrit for circle, polygon, community, connection. Literally, it means *essence* + *having, containing* or *completion*. As a circle is defined by its center, so a mandala is symbolic of balance, wholeness, and the inter-connectedness of all things.

- Discuss mandalas: There are numerous mandala examples from science (atoms, crystals), math (geometry), art and culture (Aztec, Tibetan, Hindu, Islamic art, etc.), nature (snowflakes, flowers), architecture (Bramante's Temple, Notre Dame Cathedral's stained glass windows). Also, you can talk about mandalas as a metaphor for teamwork. A personal mandala is one that contains symbols of a person's inner self, personal principles, and overall ideas about the world. The significance of objects within a mandala is conveyed by shape, size, and color. The objects can be abstract designs or specific drawings of people, places, and ideas that are central to a person's life.

Q: How can we define symmetry in nature?

Q: How can we create personal symmetry or balance in our own lives – between work, school, friends, family, fun, etc.?

Q: What happens when there is an imbalance? Why does it sometimes take a while to bring things back into balance?

- Discuss how this activity can transfer to the activity on the following page (part 2) or to the creation of their own mandalas whenever they need a relaxing activity.

CIRCLE JOURNEY
Mandala: Part 2

LEARNING GOALS

- Identify and work through fear of change
- Work through mental or emotional blocks
- Increase self-awareness and self-acceptance
- Recognize how fear can impact the students' lives and where imbalances might be

INTRODUCTION

NOTE: Part 2 of this activity allows students a deeper understanding of mandalas through the creation of their own.

Review **GROUND RULES**. Have class review the mandalas they colored from the last class, beginning with any discussion questions that you weren't able to get to.

EXTENSION ACTIVITIES

- After completing the activity in **Chill & Spill**, have students turn to the next page and write a list of the fears they expressed in the inner circle. Have students explore the ways those fears have affected their decisions or behavior by free association writing for 2-5 minutes. Ask them to focus on key words and create metaphors for them that they can use in a poem to symbolize the role that fear has played in their lives and how they can overcome it. (<u>SUPPLIES</u>: Collage materials)

- Introduce the idea of creating a balanced mandala by having students divide a circle into pie shapes, filling in each section with words (nouns) that represent things in their lives that are most important to them. (<u>SUPPLIES</u>: paper, circular plates to trace around or compasses, rulers or other straight edge tools, markers, pencils, colored pencils, pencil sharpeners)

- Teach students how to create their own mandala using a template that you create (three concentric circles on an 8.5" x 11" sheet of paper – created by hand or on the computer). Give each student

black paper and a white pencil. You may need to demonstrate use of compass and protractor. Put on calming, instrumental music and have them take the "pie" mandala words and create visual symbols from each (no words allowed).

- Create mandalas around a particular theme (healing/forgiveness, gratefulness, strengths/weaknesses, stability/change, compassion, etc.), choosing words to express different ideas, moods and feelings. Themes can also tie-in to other curriculum (e.g. Science: how can they reduce their carbon footprint?). Have students draw several concentric circles on black art paper, making sure there are irregular distances between them (some close together, some farther apart). (SUPPLIES: black or other art paper, white paint pens or white pencils, pencil sharpeners)

Student's mandala focuses on change and confusion

- Create a classroom "Cultural Wheel" by having students use colored paper that represents their country (or tribe) of origin, cutting out different meaningful shapes, and arranging them in patterns on their circle. When these circle collages are placed together around a central point, they create a larger circle; students can see how their individual efforts can synergistically combine with those around them. This "Wheel" concept can apply to nearly any classroom topic to allow students to see how he/she is connected to others in the group. (SUPPLIES: tissue paper, various colors of art paper, glue, paintbrushes, water, scissors, collage materials, ultra fine point waterproof color markers, pencils, pencil sharpeners, erasers)

Individual cultural mandalas are arranged to create a larger "wheel"

- Using one of the other mandalas as a guide, have students create an abstract mosaic mandala using unconventional materials such

as beads, beans, buttons, yarn, dried pasta, fabric, colored pieces of paper, etc. – emphasizing mood, shape or color. (SUPPLIES: cardboard base, PVA glue and brush, yarn, beads, buttons, fabric, brushes, glue, dried pasta and beans or small cut-out pieces from wrapping paper)

FOR DISCUSSION

Q: (If leading the "Cultural Wheel" activity) How did your perception of this activity change when you saw your piece as part of the whole? Discuss how each brings their own cultural background and personality to the group and how the group fits together cohesively.

Q: How does self-talk affect your daily life and decisions?

Q: How can fear affect your behavior in a negative way? In a positive way? If relevant to your students, provide education about the role of fear, discussing both the usefulness and potential destructiveness of fear. Model fact-checking to determine if fears are reasonable or unreasonable.

- Introduce the concept of physical and emotional cues (triggers) and what they look and/or feel like.

- Talk about positive versus negative ways of coping.

iNsIde ★ oF me

LEARNING GOALS

- Build a feelings and thoughts vocabulary
- Strengthen problem-solving skills

INTRODUCTION

Review **GROUND RULES**. Ask students to open up their **Chill & Spill** books to this page and write a list of everything they are thinking about for five minutes.

EXTENSION ACTIVITIES

- Introduce the concept behind a **VENN DIAGRAM** (each circle indicates the difference between two concepts, with the overlapping area showing what they have in common). Have students diagram things they think about from the past, and in the right circle, what's in their heart about the future, putting

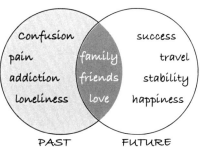

Mapping it out in a Venn Diagram can help make things clearer

 the qualities they share in the common area. Students can add as many circles to their Venn Diagram as they need to and can create different categories such as "Outside Influences" or "What other people think about me", etc.

- A week-long activity: have students record all the different things that they feel during the week and then, using this as a guide, make a map of their heart.

- Have the student create a **MULTI-FLOW MAP** pinpointing a time when they felt an overwhelming thought or emotion. Have them draw a rectangle (approximately 2"x3" inches) in the center of the page and write a short phrase that summarizes that moment. On the left side of the page, list

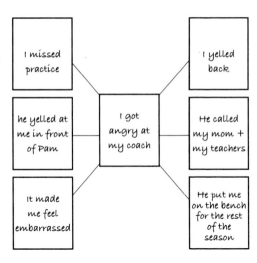

the causes and on the right side, show the effects or consequences that happened as a result.

- Self Portrait Silhouette: Pair up students. Placing a lamp or an overhead projector on a table about 6 feet from a blank wall, have students stand against the wall so their profile casts a shadow. Tape a piece of 8.5" x 11" card stock or paper to the wall and have their partner trace the silhouette. When the tracing is complete, ask them to color, draw or write their thoughts inside the face, asking them to show how much space each thought occupies. (SUPPLIES: oil pastels, art paper, lamp or projector, tape)

Cast a shadow of the student's profile on the wall for this activity

- Introduce the concept of a **MIND MAP** as a way of sorting out ideas. Then have students make a "playlist" of songs that represent values, thoughts, and aspirations, writing descriptions of why they relate to each of the songs. Then select a favorite song and map out the feelings contained in the lyrics.

- Discuss the parts of the brain – how it stores memories, smells, etc. Remind students about the linear aspects of the Left Brain and the artistic qualities of the Right Brain. Ask, "If we could look inside

your brain what would it tells us; what would we see? What things are stored inside your brain that would help us learn about you? What things do you have planned for your future? Where do you want to go?" If time is limited, have students draw an elongated oval, representing the brain, and divide it into two parts: on the left, have students draw things that are structured in their lives (include things important to them about school/society including rules, time, math, logic, planning, goals, technology, etc.). In the right half, have them draw feelings, emotions, things they daydream about, creativity, relationships, humor, etc. If time is not an issue, use the same concept in the activity below.

- Have students separate and draw each of their primary emotions as "tame beasts" or "wild animals."

This student shows sadness as a lion they want to tame

- Discuss ancient Greek Theatre masks that depict contrasting emotions (comedy/tragedy). Characters donned these masks so that audiences could easily identify the character or emotion the actor was depicting. Ready-made paper maché, porcelain, or plastic masks can be used or, if in an art class, paper or plaster casting material may be used. Paint the resulting masks according to emotions they want to portray. Masks can be used to help students express emotions they normally hide. (SUPPLIES: Store-bought ready-made mask blank or pieces of sheet foam to create flat masks, acrylic paint supplies, waterproof color markers, found objects)

Students started with a list, then transferred the concepts onto thumbnail sketches of masks before moving onto painting

- Review the work of Joseph Cornell and other artists who have used **FOUND OBJECTS** to express concepts, thoughts and emotions. Have students bring in a box with a hinged lid or a removable lid (these

can be made of wood or sturdy cardboard, such as shoe boxes, cigar boxes or the metal boxes that mints sometimes come in) that they can alter/paint. Ask students to use what they wrote in **Chill & Spill** to plan a design of their box on paper before they begin – planning both the inside (representing what's in their heart) and outside of the box (what's in their head). They can additionally brainstorm lists of themes, messages, or personal statements that can also be used. Using mixed media materials, create an assemblage representing the themes. Have students collect collage materials, and perhaps bring items from home that can be part of the project. Images inside the box can be three-dimensional or be placed in layers to simulate a theatrical stage.

- If you are working with students with body-image issues, modify this exercise by having students project and work with shapes. Avoid geometric shapes and use the shapes of leaves, branches, ferns or abstract squiggles. If you still have an overhead projector around, use it to project shapes on the wall for students to trace and work with.

FOR DISCUSSION

Q: What happens when you let either your thoughts or your emotions lead? What happens when your thoughts and feelings don't agree? What do you do then?

Q: Are there certain thoughts that take up a large portion of your time? Are the thoughts disturbing or intrusive? (Be sure to refer to the counseling staff if students report intrusive or troubling thoughts connected with a traumatic event)

Q: Does it ever seem like your heart and your brain want different things? How do you decide which one to listen to? What would it be like if you were "all heart" or "all brain?"

personal lifeline

LEARNING GOALS

- Creates recognition of pattern and perspective by honoring and exploring life events

INTRODUCTION

Review **GROUND RULES**. Some educators allow at least two – if not three – sessions for this activity, beginning by focusing on the students' first 3-5 years of life and work up from there. This activity can use journaling, drawing, symbology, collaging personal pictures, research on computer... any object that supports the memory. It can be taken slowly to allow lots of time to remember and honor memories. NOTE: Because this activity has the potential for opening up painful histories, the educator should model limited disclosure.

EXTENSION ACTIVITIES FOR INDIVIDUALS

- Student chooses colors that represent glad, sad and mad and highlights each event in his/her time-line to represent the associated feelings. Ask them to notice any patterns that become evident. (SUPPLIES: Four different colors of highlighters or markers per person; graph paper)

- On a second piece of paper, have students draw a graph showing more detail about life events in chronological order, mapping out things that affected them positively above the median and events that affected them negatively below the median.

- **Wire Figures**: Have students review their lifeline and identify someone who made a positive impact in their life. Have students make a free-form figure to represent them, using found wood and wire, wrapping and pinching the wire to create expressive gestures and poses, adding limbs, hair and other embellishments as appropriate. The "portraits" can be as simple

Driftwood people can help inspire stories of heroes in their life

or elaborate as time and material budgets allow. Ask the students to write a story about who their figure is and what made them such an important person in their life. Ask them to identify character values that person has. (<u>SUPPLIES</u>: beads, wire cutters, 20-22 gauge wire, telephone wire, driftwood or twigs of various sizes, awl)

• Have students create an imaginary lifeline starting tomorrow, reflecting the next 10 years. Encourage them to draw pictures and icons/symbols/logos in place of words indicating challenges, joys, dreams, using color to help associate feelings with new events.

FOR DISCUSSION

Q: Do you see any patterns, feelings, situations that seem to appear time and time again? Do they have anything to do with certain people, places or things or do they seem random?

Q: Are there long periods of time that you remember being glad, sad or mad? Are they connected with events on the lifeline?

Q: When good or bad things happen in your life, how do you normally react? Do you have anything special to celebrate when good things happen, or anything that helps you feel better when you experience bad things?

Q: What have you learned from things that have happened to you? How do you overcome difficult circumstances? How does what you've learned from the past change future decisions?

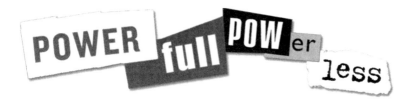

LEARNING GOALS

- Develop personal symbology
- Increase viewing of self as powerful and capable
- Increase self-awareness

INTRODUCTION

Review **GROUND RULES**. Open **Chill & Spill** book to this page, read activity. Ask students to make a two-column list in their journals of all the situations that make them feel powerless and powerful – ask them not to edit, just to write.

Discuss symbology of some main words they are willing to share and how they might be able to represent those things in **WIRE SCULPTURE**. Show examples of various artists whose sculptural work is clearly self-expressive (examples include Alexander Calder, James Surls, Terry Border, Marshall Fredericks, Elizabeth Berrien, and Billy Makhubela).

Discuss how Marshall Fredericks, for example, sketched out ideas before he sculpted them (many of his drawings have been archived and are accessible) and how his inspiration came from things he read, things he saw, and things he encountered in his life.

Like Mr. Fredericks, guide your students to think about the two words and list the situations that make them feel "Powerful" and "Powerless." Ask them to re-read their lists and highlight words that are especially significant. From those words, they will do thumbnail sketches of simple images that represent these concepts. For instance, when their baby brother can't be comforted, they feel powerless. They might represent that concept visually by drawing a tear shape, or an open mouth screaming, or a sad baby. And perhaps when they shoot a basket and people cheer, they feel powerful. From these simple sketches, students can move onto the next stage of the extension activities.

EXTENSION ACTIVITIES

- Choose other word pairs that are significant to the students to illustrate (for example: victor/victim, freedom/addiction, love/hate, accomplishment/failure, etc.). Create a book full of opposites, having them create a cover for the book with a title.

- Create a collage without using magazines or "ready-made images": only use scraps such as old bus schedules, candy wrappers, foreign newspapers, movie tickets, recycled office paper, etc. The challenge will be to only allow visual representations of the theme, and not use printed words or "easy" images to communicate. (<u>SUPPLIES</u>: collage materials)

- **Altered Book**:[9] Give each student an old, hard-cover book that has paper that isn't too thin and can withstand gluing and painting. Ask students to look through the first few pages of the book, searching for words and phrases that can be used to communicate personal power. These words should either be left alone, with color added around them, or highlighted with a light color (see example on the right that shows both ways). Students use a variety of artistic media to alter the book, creating a statement about personal power.

Highlight words in the book's text to form a statement or poem

NOTE: Remind students not to get the pages too wet otherwise the pages will wrinkle; also remind them to make sure the page is completely dry before shutting the book. Once dry, slip a piece of wax paper in between the pages before closing the book and then place a heavy object on top to smooth out any wrinkles (the wax paper keeps the page from sticking to the facing page just in case there is still some moisture). Once the page is dry and wrinkle-free as much as possible, lightly spray the page with a matte finish to protect it. This method can be used for any number of projects, using

9 Illustration, this page, by Steffanie Lorig during a Powerful/Powerless Chill & Spill class

the same book. For additional ideas, refer to any of the number of wonderful reference art books available at your local library about the many ways to alter books. (SUPPLIES: hard-backed books, glue, acrylic paint supplies, colored pencils, pencil sharpener, highlighters of various colors, ink, watercolor crayons, gesso, rubber stamps, collage materials)

- Distribute materials for wire sculpture including many different thicknesses and colors of wire to create at least one, if not two sculptures depicting "Powerful" and "Powerless." Show them examples of the differences between outline, contour line and gesture lines. Starting from the sketches they have done, ask them to recreate their favorite sketches as continuous line drawings, exploring both full and partial figures. (SUPPLIES: wire sculpture supplies)[10]

A continuous line drawing can help students simplify their sketches and concepts

- Have students trace a hand and part of their arm, and draw (or "tattoo") things they have achieved as well as things they are still reaching for in their lives.

- Have students write a scene of a play or a poem based on their artwork, which can then be acted out or read aloud. Have students play with the idea of extremes, discussing or acting out different scenes that illustrate concepts of power vs. powerlessness. It is the group's responsibility to resolve each act, ending at a point of balance.

- Temporary art installation: limit size of collages to 6" x 6" or smaller. When students are done, gather them together into one large art installation, taping collages to the board or wall. Discuss how there is power in numbers and community. (SUPPLIES: collage materials)

10 Illustration, this page, by Steffanie Lorig

FOR DISCUSSION

Q: How do these images demonstrate power/powerlessness?

Q: When in your life have you felt the most powerful? The most powerless?

Q: What healthy ways can you use feelings of powerfulness and powerlessness? What are unhealthy ways of using these feelings?

- Pay attention to symbols that present themselves and ask open-ended questions, letting the student lead the discussion about the metaphors/meaning behind the images they chose.

- Explore the topic of duality of feeling: two vastly different emotions in the same person.

An Educator's Companion to Chill & Spill

Action | Reaction

LEARNING GOALS

- Identify "hot buttons," triggers or cues that lead to behavior students want to avoid
- Increase awareness of physical and emotional clues
- Learn and practice emotional regulation and coping skills

INTRODUCTION

Review **GROUND RULES**. Ask each student to privately work in their **Chill & Spill** book for 15-20 minutes. Help them grasp the concept by drawing the chart indicated in the journal, and asking students to call out situations they've seen on TV or movies where something led to an emotional response that got out of hand (or, alternatively, you can show the class a scene from a movie and ask them to write about this topic). Help them work from that point backwards to identify what the real issue is (e.g. was fear, shame, or loneliness at the root of the angry outburst?). Together brainstorm alternative, healthier choices for those characters. This is an appropriate time to discuss post-traumatic stress disorder, perhaps focusing on soldiers returning from war.

EXTENSION ACTIVITIES

- Ask students to draw a thermometer and label different emotions as hot, cold, or lukewarm. Ask them to evaluate these emotions and what message they are sending out about what they are thinking, believing, etc.

- Ask students to create two different collages depicting the different paths we can take when faced with an emotional cue: one that represents effective behavior and one that represents behavior that creates more problems.

- Call out different situations (your sister breaks your favorite CD, your mom glares at you while you're on the phone, your dad shows your friends embarrassing photos, your close friend spreads gossip about you or someone else) and have student pairs role play alternate responses and act out a more positive outcome.

- Have students create a pros and cons chart for their different reactions, labeling each as healthy or unhealthy. Explore what behaviors "work" for them, what they gain or lose by acting that way and what they would gain or lose by giving the behavior(s) up.

FOR DISCUSSION

Q: When this situation happens, what would you like to have happen?

Q: If you can't change your circumstance, what can you change? Do you have choices?

- Discuss the difference between victim and victor – how can people become empowered by choices instead of being a victim of reactions?

- Discuss decision-making, impulsive behavior, consequences and the relationship between them (cause/effect, action/reaction, empowerment/discouragement).

LEARNING GOALS

- Build self-awareness and encourage self-discovery

INTRODUCTION

Review **GROUND RULES**. Have students start the activity directly in **Chill & Spill**. Ask them to place a blank notebook by their bedside to write about any dreams they have for the next two weeks. Let them know that even dream fragments or feelings upon waking should be recorded through words and pictures. Explain that dream images (symbols) are the language of our subconscious minds, and that each person's symbolic language is unique. Encourage students to interpret their own dreams and the symbols that may appear.

EXTENSION ACTIVITIES

- After recording their dreams, ask students to examine what they have written and notice any reoccurring themes, patterns, feelings, textures, characters, etc. Ask them to write about what they think each of these things represents.

- Give each student fabric markers and a pillowcase, and ask him/her to draw a picture of a favorite dream – what they looked like, where they were or simply the feeling they felt while in the dream. (SUPPLIES: cotton pillowcases, fabric markers, fabric paint, brushes, cardboard to fit inside the case to prevent bleeding)

- Provide the class with large cut-out stars and ask them to write down words that remind them of their favorite dreams, goals or wishes. Tape them to the ceiling to remind the group of their aspirations. (SUPPLIES: stiff yellow paper, thick-tipped markers, double-sided foam tape)

- Ask students to take one dream that empowered them or made them happy and re-create the feeling through a painting (SUPPLIES: acrylic paint supplies)

- **Tin Shrine**: Ask students to create a treasure box out of discarded cookie or mint tins. Lightly sand the tin down to give it a "tooth" (texture). Paint gesso on the outside of the entire tin. Let it dry for at least 24 hours (Note: If you would rather skip the sanding/priming step, there are paints specifically made for metal. Visit your local craft store to find a product that will work). Using acrylics, create a painting on the outside of the tin. Once dry, embellish the tin using hot glue as the adhesive. If there are a lot of items added, add a layer of decoupage medium over the entire thing to give it an extra bond and an added sheen (if you choose glossy medium). Add the medium in thin layers until the entire piece is sealed and sturdy. Allow the piece to dry 24-48 hours. Students can now use the treasure box to place any dreams and wishes they write down. (SUPPLIES: tin box, gesso, paintbrush, acrylic paint, craft glue, glossy medium)

Dreams can reveal things we weren't full aware of yet

FOR DISCUSSION

Q: What do your dreams mean to you? What symbols, people or themes have you noticed show up more than once? What do your dreams tell you about what you are going through right now?

- Encourage students to explore what their dreams are trying to tell them. Discuss the idea that everything the dreamer dreams is about the dreamer. From this perspective, what can be learned?

- Talk about the "crazy" or bizarre dreams people have; look for common themes. Explore the phenomena of universal themes, like coming to school naked, losing one's teeth, falling or flying.

An Educator's Companion to Chill & Spill

Shoulda Woulda Coulda

LEARNING GOALS

- Identify and externalize negative thoughts (the Inner Critic)
- Learn to discern the difference between thoughts that are helpful and hurtful

INTRODUCTION

Review **GROUND RULES**. Begin class by discussing negative and positive self-talk (the inner chatter that tends to shows up just as we are about to embark on a new project or challenge). Ask students to think of examples from their own lives or from characters from books. Talk briefly about how our inner dialogue changes what we do sometimes, how it can increase our stress levels, or limit our potential. (Example: If you say "I can't handle this," you more than likely can't or won't even begin to try to look for solutions). Ask students to think of examples of negative self-talk that turned into a self-fulfilling prophecy. This voice tends to be the loudest when we are feeling insecure about what we are doing or saying.

Open up **Chill & Spill** journals to this page and follow the instructions to create a list of negative and positive messages they tell themselves. Allow 10-15 minutes to complete this. Ask if students could share some of their discoveries. Write down common themes on the board.

At the end of class, assign HOMEWORK: using prompts from **The Last Word** write a private letter to a habit you would like to break.

EXTENSION ACTIVITIES

- In a loose and relaxed state, and a different color marker in each hand, ask students to use their non-dominant hand to draw or write negative messages they hear from their Inner Critic, and have them respond to the criticism with their dominant hand.

- Discuss the elements of storytelling, emphasizing how graphic novels and comic strips distill the story down to the basic elements. Show short examples, discussing how the artist tells the story with pictures. Ask them to choose the message that is most troubling to them and, using the cartoon character they created in the initial activity, create a comic strip using humor to gain power. Then ask students to sketch ideas for the positive voice, things they need to remind themselves to defeat their Inner Critic.

- Ask students to write down an impression that people have about them that isn't true. Ask them to complete this sentence: "If I could change one thing about how people feel about students like me, it would be..." Discuss how prejudice affects daily life.

The frame contains positive messages that the student wants to remind herself of

- Using a wooden frame with a mirror, have students paint positive messages to themselves. Students can also collage the frame with cut out words from various magazines that carry a positive message. (SUPPLIES: acrylic paint supplies, wooden frame with mirror, available at craft supply stores, pencils, thin and thick-nibbed waterproof color pens)

- Ask them to keep a daily log, recording the messages they hear from their inner critic as they occur, noting details such as time of day, who was present, where they were, etc. Make note of patterns that begin to emerge.

- Have them write a "pink slip" (letter of dismissal) to the Inner Critic, remembering to thank them for their past help. Then have them write a new job description, which will better serve their current needs and interests.

- Give students 3x5" index cards and a cheap index card file (available at office supply stores) to create comic-book characters with names that depict the Inner Critic (villains) as well as characters that depict the heroes, those with power who can face upcoming challenges in their lives. For each new "critic" that appears in their lives, they draw

a corresponding hero, keeping note of them all semester or year. (SUPPLIES: index cards and holder)

- On a chalkboard or dry-erase board, have students write or draw images of their negative self-talk. Then ask them to erase and "re-record" the message with words from a wiser perspective.

- If you have access to a shredder, ask students to write/draw images of their negative self-talk or their Inner critic. Allow students to ceremoniously feed the words and images through the shredder.

FOR DISCUSSION

Q: Why is it important to recognize what your inner critic is saying to you? (You have to know your enemy to fight it; until you can hear all of its insults, you won't know when or how to fight back.) What are the consequences of listening to the negative things it says?

Q: What happens when we listen to the Inner Critic? What do we lose/gain from listening to it?

Q: Being able to evaluate our strengths and weaknesses, or our best and worst behaviors is very important. What are good sources of information to help us figure out where we need to grow and improve?

Q: What's good about fear and when does fear hold us back? Discuss the function of fear.

Q: Why is discernment between positive and negative messages an important thing? What happens when you don't differentiate between self-talk that lifts us up or self-talk that drags us down?

LEARNING GOALS

- Healthy communication
- Helps process grief and loss

INTRODUCTION

Review **GROUND RULES**. Remind students that the last class is coming up next week. This activity may be a private and worked on individually. Tell students they are going to write a letter saying goodbye to something or someone. Tell them that they don't need to choose someone who has died, or moved away – it can even be a habit they let go of, or a place they no longer live or visit, or a time in their life that has passed. As you read the prompts from this activity aloud, allow approximately two minutes for students to write after each prompt, giving additional time as needed, noting that this activity may bring up very private feelings.

EXTENSION ACTIVITIES

- After they have completed the first letter in their journal, ask students switch roles (they are now the person they wrote to originally) and write a letter to themselves from that person's perspective.

- Have the student think of another "ghost" they need to let go of and forgive from their past and write a secondary letter to that person, habit or event.

- Using "The Last Word" template as a guide, have each individual privately identify something they want to let go of and haven't yet (a habit, behavior, relationship, goal or something they've outgrown) and write a letter to it. Have them go to the center of the group circle and verbally share a synopsis of what they are releasing. Have them dispose of their letter in a manner appropriate to their feelings. Sharing can help normalize their experiences and helps deepen their learning from each other.

An Educator's Companion to Chill & Spill

- Ask students to take one of the situations they wrote about and draw not only what they lost, but the "unasked for gifts" that they received as well (they may have lost their best friend after the move, but they gained new confidence). (SUPPLIES: colored markers, color pencils, pencil sharpeners)

This student represented both what she lost and what she gained from a personal situation

- Have students create a symbol or drawing of their loss out of natural objects (chalk on a rock, draw in the sand, twigs and twine, dried beans, pebbles, etc.). Bring the objects outside to a quiet spot and give students time to reflect on the gifts they received from this loss before releasing it and leaving it behind in the elements. In a week, have students go back and visit the spot to see how nature changed their objects. (SUPPLIES: Trash can; chalk and rocks, twigs and twine, water soluble color markers and paper, or other natural materials)

FOR DISCUSSION

Q: How are you different now than before this change, loss or transition?

Q: Why is it important that we acknowledge loss? What happens if we don't?

Q: What do you think you gained from this loss? How did it strengthen you? What lessons did you learn from it?

Q: Why is gratefulness important? Why should we acknowledge that gift before we release it? How does being thankful affect your of peace of mind? Discuss gratitude's role.

- It is sometimes difficult to see that letting go is not the same as saying that something didn't hurt or wasn't a big deal. Explore the difference between acceptance and approval.

LEARNING GOALS

- Encourages problem-solving skills, allowing students to move from problem-focused thinking to solution-focused thinking
- Allows the student to gain a greater perspective of their current struggles and life issues by defining a problem in words, shapes, texture and symbols

INTRODUCTION

Review **GROUND RULES**. Open up to **Chill & Spill** and ask students to write a list of goals they have for this week (ace the math test), month (score a goal in soccer), this year, and/or for their lifetime. Allow them five minutes to complete.

Discuss the importance of goal setting, but also of mapping out the different steps they will need along the journey. Ask students to call out some life goals and write them on the board. Ask students to help you differentiate between realistic goals that can be achieved within a time frame and (almost) impossible dreams. Choose one or two ideas that seem attainable and ask for students to help you identify the steps someone would need to take to get to this goal (e.g. if the goal is to live in Africa someday, they would need to start raising money, research about the customs, learn the language of the tribe or area they want to be with, etc.).

Then break down each of those steps into smaller steps (e.g. to raise the money, they would need to find a job that has a decent wage, maybe make things to sell, etc.). Show them how this now becomes a plan of action.

Ask students to write their own plan of action for their top goals in each of the categories (this week, this month, this year, in the future). Make

sure each student leaves this session with a clear plan for taking the first step toward at least one of their goals.

This is the last activity in the unit. Spend some time planning for how they would like to spend the next session, which will be the culminating session of the experience. Possibilities include: make-up time for unfinished projects, a gallery show of one or two of each student's favorite pieces, an extended sharing time to talk about the whole experience, sharing whatever pieces they would like to show. This is also your last chance to scan or photograph the most interesting examples of work that you can use to share with future classes (and, as requested previouly, to share with Art with Heart).

EXTENSION ACTIVITIES

* Have students identify the various people who make up their support system (include people in helping roles, nurturing roles as well as friends and family who are helpful) and write or draw what support looks like from each of those people (they can include animals!).

* Ask students to make a list of items they would want to bring in their backpack or suitcase on this journey across the bridge and write how each item would help them reach their destination.

* **Mixed-media painting**: Have students create a horizontal painting of what their bridge looks like on gessoed masonite. Ask students to select small or flat objects that are symbolic to them and incorporate by gluing them directly on top of the dried painting to "build the bridge" and make it stronger. Students can apply paint over the objects to unify the painting if desired. (SUPPLIES: acrylic paint supplies, small found objects, strong glue, masonite, gesso)

* **Altered Shoes**: Students will transform an old shoe or boot they no longer wear. Do research ahead of time using the internet and type in key words for images of "painted shoes" or "art shoes" that you can print out and share with the class as examples. The concept behind this project is to represent where they are going in their future.

 Have students do thumbnail sketches to work out their ideas on paper first. The shoe no longer needs to be physically wearable, but must maintain the original physical integrity. Provide small found objects – old jewelry, acrylic or fabric paint, beads, lace, wire, etc. – that students can attach to the shoe to help illustrate their concept.

If students want to paint the shoes, a layer of gesso will need to be applied first to keep the paint from soaking in). (SUPPLIES: Old shoes from thrift stores/yard sales–various types ranging from work boots to ballet slippers to gardening clogs, or all canvas types, gesso, found objects, acrylic paint supplies, craft glue or hot glue guns, paint pens)

- Using wire, clay, or found objects, have them create a 3-D bridge including a figure of themselves. Ask each student to take the journey across the bridge both figuratively and literally. The found objects could be natural items found around the school such as twigs, rocks, etc. (SUPPLIES: found objects, wire or clay with pottery tools)

- Ask the group to form two rows facing each other, creating a human bridge. Ask one student to take a step towards the bridge, while their peers throw out a pertinent verbal obstacles: "What are you going to do the next time someone calls you stupid?", "What are you going to do when someone calls you up to go drinking?" or "What are you going to do at a party when you see your old friends using?" Ask the student to respond. They cannot take another step unless they successfully verbally answer/overcome the last obstacle. If they don't have a response, you can ask others to offer positive and constructive suggestions.

FOR DISCUSSION

- The bridge is a metaphor for the student's sense of stability and security. Explore what the bridge is made of and where they place themselves on it. Have they begun the journey yet? Is it a long journey? What are the risks (what's under the bridge)? If they haven't started on the bridge yet, they may not yet know how they are going to achieve their goal.

- Notice how solid and stable the bridge is: how is it supported? Discuss how to strengthen the bridge to make the journey successful. Ask about support systems: what does each person need to make it through? Have students physically add more to their bridge drawings or sculptures to add more strength.

- **Q:** What do you want to be doing in six months? In one year? When you're done with middle school/high school/college? What will motivate you to get to where you want to go?

Q: What could keep us from taking the first step? Can we succeed without failure? How does success cause fear or additional pressure? Discuss fear of failure/success, risk taking, and trusting the process of our own individual journeys.

Q: Why are goals important? How do you make/keep goals? What makes a goal realistic? Is it okay if your goals are not realistic?

Q: What new thoughts or actions can help you achieve your goals?

CHAPTER 5

ADDITIONAL RESOURCES

Timetable

This chapter is organized in the same order in which you would run the Chill & Spill unit.

1. **If this is your first session with Chill & Spill, review the following:**
 a. "Everyone Gets A Copy!" (page 13)
 b. "Developing a Supportive, Creative Environment" (page 20)
 c. "Introducing Chill & Spill to Students" (page 22)
 d. "A Word about Materials" and "Items to Have on Hand" (pgs 42-49)

2. **Gather and set up the supplies:**
 a. If you are unfamiliar with art supplies, review the "Tips & Tricks" sections (page 50-60) and decide which media you will use.
 b. Review your activity in the "Extension Activities" Chapter (starting on page 52) to reference what you would like to do to extend the lesson.
 c. Gather supplies and arrange them.

3. **Open Chill & Spill books to the activity of the day:**
 a. Give students five minutes to write, giving prompts from the activity.
 b. Ask them to choose words that "stick out" to them and begin thinking about what those words "look like" visually. This will help them make the creative leap to the next portion.
 c. Show sample artwork: show diverse, non-traditional examples to give students an idea of the wide range of possibilities (page 23).
 d. Introduce supplies and demonstrate how to use the medium.

5. **Do the activity together** (page 25):
 a. Review "Coaching Creativity" through "Talking to Students About Their Art" (pages 26-35)
 b. Sharing time: review the discussion questions from the activity (page 37)
 c. Clean up together (page 37).
 d. Preview what you will be doing in the next class.
 e. Keep artwork till end of semester, taking photos of finished artwork (page 37-38)
 f. Evaluate: write down how it went, what you would do differently next time, things you learned, etc.
 g. At the end of the semester, hand out evaluation forms (page 127-128)

Evaluation Study

Since **Chill & Spill** was first published in 2005, Art with Heart has been collecting evaluative data in order to provide both statistical and anecdotal information showing **Chill & Spill**'s effectiveness.

Anecdotal evidence from professionals to date suggests that adolescents who use **Chill & Spill** display increased self-esteem, self-awareness, and self-expression.

In February 2006, Art with Heart surveyed professionals in six states who used **Chill & Spill** in their work with a total of 796 teens who were considered "hard-to-communicate-with" and "anxious."

- 38% of the survey participants said that the book helped reduce symptoms of depression

- 50% said it increased the teens' personal insights

- 75% said it allowed for greater self-expression

- 25% reported that students they worked with were happier

- 38% said students were easier to communicate with after using **Chill & Spill**

This is a significant improvement given that 67% of the teens surveyed had been expelled from school and were considered to have severe behavior problems.

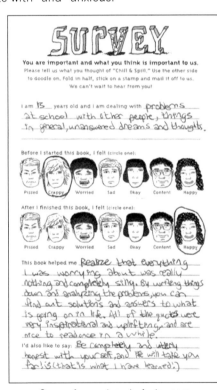

Survey from a teen in foster care

As the Educator's Companion to **Chill & Spill** is being written, Art with Heart is midway through a more comprehensive evaluation study with seven sites, including schools and youth care organizations. Initial reports indicate that youth in the study self-report using **Chill & Spill** to deal with things that are painful, scary or difficult. Over 80% of all youth

in the preliminary evaluation report that **Chill & Spill** helps them:

- Make better choices in their lives.
- Feel better about their situation.
- Taught them things they weren't aware of before.
- Talk about things in their lives.
- Figure out their feelings.

While the study is ongoing, educators, therapists, counselors and prevention specialists who received training as part of the evaluation study have already reported that:

- There were **high levels of youth engagement** in the **Chill & Spill** activities. "All of the participants were excited to keep their books and look forward to working in the future." Another facilitator shared, "I was surprised at how much information the youth wanted to share, much of it was information I was not aware of and these are youth I know well."

- **Chill & Spill** is a particularly **effective way to engage a young person in a meaningful level of honest dialogue**. "It helped bridge a gap and break barriers away between me and the participants. My sharing with them helped them be more comfortable with me."

- Youth **learn about themselves, share their ideas and feelings and think about their futures** while using Chill & Spill. "It's a great tool for anyone working to help young people process their experiences and become more self-aware. It's especially helpful for students who struggle expressing them selves in words or students who love art."

- Chill & Spill is a **powerful, healthy coping tool** to address everyday teen challenges as well as extreme trauma and stress. "I am always looking for ways to help students positively cope with the challenges in their life. Positive coping skills are a huge protective factor against drug and alcohol use. **Chill & Spill** was a positive coping tool to introduce to the participants."

Chill & Spill program evaluation tools are available for your school. Your feedback will help us track program success. This data can also be utilized to demonstrate program success to school administrators. Email us for more information at info@artwithheart.org.

Quotes from Students

- "I found that I am **more creative** in Chill & Spill than I am in my Creative Writing class!"

- "I like my Chill & Spill class because it's the only class we have where we get to **talk about ourselves and express what's going on inside of us.**"

- "I have learned how to **express my emotions** in positive ways. The Chill & Spill book helped me with that."

- "As a foster care youth, I am constantly bombarded with really hard things that I constantly have to swallow down. I never have a chance to really **examine** how they all build up and affect my attitude. This workshop and this book have really helped me realize that I have a lot of things I need to pay attention to."

- "I am 13 and dealing with teasing and being yelled at and stuff like that. Chill & Spill **helped me with letting my feelings out**. And that's really a big step for me."

- "My mother was taken away from me and I'm worried that I might not get to see her ever again. But Chill & Spill helped me get all my emotions out and **helped me be more content with my life**."

- "The best thing about Chill & Spill is that it lets you **share and spill** how you feel about life."

- "Chill & Spill helped me through a lot of stuff. It wasn't just an ordinary journal where you just write your feelings down. **It talked back to you**. Instead of just writing stuff down and reading it over, it actually had some stuff to tell you after what you told it."

- "I am 10 and I like this book because it can **help me with stuff I'm struggling with**. And it is very, very **fun**."

- "I was surprised to see that I was **more honest with myself** in this journal than I ever have been before."

- "I loved this workshop because it's very **interactive** and hands-on and we learned a lot about ourselves. It was awesome!"

- "When I come to Chill & Spill, it's like I'm in heaven or something because it's so **peaceful** and stuff."

- "There are days when things are really bothering me and Chill & Spill gives me a good place to put everything down. It asks you to think about things and the **changes** you need to make in your life to make it better."

- "I use it a lot to write about things that make me frustrated. Instead of being mad, I can just write in Chill & Spill until I feel better. That way I don't lose friends because I'm grouchy."

- "It's been a **powerful tool** to help me heal from my past, as well as from things I'm dealing with now. It helps me express things I can't say out loud."

Quotes from Educators, Counselors and Others

- "it is exciting to see **students learn from each others' experiences** and realize they aren't alone. The activities gave my students a **structure** in which to write their thoughts and feelings. We use Chill & Spill every week in both the junior high and high school groups at my school."

- "Having our students learn shading and perspective is nice and all, but it's not a skill that is going to benefit 99% them in the long run. The students in the Chill & Spill class see it as **a way to communicate**. The work is rich. I'm grateful that the students have a space for creativity as well as **reflection** and **expression** of the multitude of issues they carry with them."

- "Chill & Spill is a great **outlet** for students to express themselves in, especially students who don't do well with reading or writing or are tired of talking about their problem. It gives them **a sense of autonomy and control**, and that's really important."

- "I have found it valuable to have copies of Chill & Spill on hand. It is a great tool for students that need a safe outlet for their feelings. The book also gives students ideas on **how to continue to help themselves in the future**. I've received positive feedback from all the students I have given the book to."

- "The change we see in the students because of Chill & Spill is extraordinary. The only problem is that we don't have enough! The book has become our **number one priority** in our list of things to do with the students and to find funding for."

- "This book provides the instrument that many teens need to **externalize** their feelings so that they might **better understand themselves** and resolve the issues that so often trouble them. It encourages the best kind of reflection and is destined to make an impact for good among young people going through a difficult time of life."

- "There's an activity in Chill & Spill called 'ACTION/REACTION' – it's all about teaching students how to **identify their emotional triggers**. Through the activity, I asked this particular student to diagram what makes him feel 'out of control' both physically and emotionally. He wrote very little. Instead, he drew and colored a lot. To show how he felt before he hit someone, he ended up drawing fire coming out of his hands. He had never realized that he had this burning sensation before this activity. It was a huge revelation to him to be able to connect the tingling in his hands to the onset of a violent episode. **This was his first step toward gaining control of his anger**. Before he didn't know that he had a choice · someone made him mad, and he hit them. Now, he knew that he had choices. Chill & Spill was hugely instrumental in allowing him to become aware of, express and manage his anger. For him, this was life changing."

- "The wonderful illustrations and teen-friendly exercises are well-developed and helpful for **sparking creative thought**."

- "I did Chill & Spill with a 15 year old who had just been removed from her home and placed in foster care. One of the activities in the book asks participants in writing a letter to someone. She chose to write it to her dad. When she was done, she said, 'I want you to read it. I want you to see it.' You could physically see the relief that the activity had given her **a place to express her deepest needs, desires and thoughts**. And I had told her in the beginning that I didn't need to look at anything she did in the book, that we would just talk about what it felt like and what she learned about herself. I thought it was amazing that she WANTED me to see!"

- "It helps students **look at the questions** about their lives in a different way. Their answers become different too."

- "Chill & Spill is a well-researched and very usable resource for working with teens and young adults who are suffering from depression, trauma and stress. I would recommend it to anyone

wanting **a hip, creative way to help students** deal with their emotions and channel their feelings in appropriate ways."

- "I have been so busy helping all the students that doing this really helped me realize that I have been neglecting my own emotional needs, so **I use it too!**"

- "Creative expression is a powerful tool – it helps children express the inexpressible and develop the critical skills of understanding and managing their emotions. ...Art with Heart's work is **not merely enrichment or an add-on,** but a whole curriculum that is a significant contribution to a student's complete emotional well-being."

- "After working through Chill & Spill, a student told me that she has been able to make new friends because **she feels more confident in herself.** She uses the book to express her feelings without being judged by others."

- "I wish I had had something like this during my own adolescence. I wanted to be artistic but wasn't confident in my abilities. I wanted to get my thoughts out in writing but was too embarrassed to keep a diary or a journal. This book provides space for both without the guilt of either, as well as fun, interesting exercises to build confidence and a **positive self-image** without sounding 'cheesy' or 'lame' to youths."

- "I gave a book to a student during our weekly high school group for youth affected by cancer. She was a very private fifteen year-old whose mother was undergoing a stem cell transplant for leukemia. She finished "Inside of Me" during the group session and then volunteered to share her entry with the group. Sally shared that she was experiencing feelings of loss, fear, anger and hopelessness. Her sharing **sparked a conversation** amongst her peers that normalized her feelings and helped other students express themselves as well."

- "Chris, our male educator who works with a middle school boy's group took Chill & Spill with him for the first time. The day before, we had brainstormed about various scenarios that might happen and how he could facilitate the process. And, truth be known, he was preparing himself for the worst (in case they didn't like the book). Well, he came back AMAZED and DELIGHTED. **The boys were thrilled** from the moment they laid eyes on the book. They quickly took them out of the shrink-wrap, commented on every picture. Some of the

An Educator's Companion to Chill & Spill

students started the first activity before Chris was even done handing them out. Chris had to shove the guys out the door because they wanted to stay and write, but if they did that, they would be late for the next class. He had to force them to shut the book and promise not to take it out in their next class!"

- "As a drug and alcohol prevention specialist, I am always looking for ways to help students positively cope with the challenges in their life. Positive coping skills are a huge protective factor against drug and alcohol use. Chill & Spill was a **positive coping tool** to introduce to the participants and students in my Chill & Spill group enjoy the book so much that they are telling their friends that they should do it too. That's a big deal for them to feel like their counseling group isn't something to be ashamed of..."

- "You can sense the **building blocks of sequential growth** as the students mature through the book as they progress to the next step in their life."

- "It has helped me **connect with my teens** in amazing ways. For instance, 'Heather's' therapist told me that she had been trying for two years to get her to open up, but to no avail. I thought immediately of Chill & Spill and started using it with her right away. Right away, she connected to it. As we worked through the book, Heather began to **trust the process** and a ton of stuff came 'spilling' out as she kept exploring Chill & Spill. You could see as she continued to work through the book, that many burdens she had been carrying around with her had been lifted. It's been truly amazing to see how **she has blossomed**. Maybe we would have eventually gotten there on our own, but I certainly wouldn't have been able to get there as quick as we were able to because of Chill & Spill. She was able to connect with her self and figure out what she needed."

- "Chill & Spill helps reveal deep-seated issues, and is able to display them in such a way that we can talk about it at team meetings; allowing social workers to incorporate it into their treatment planning. Chill & Spill gives the students a base to talk about their feelings and discuss what's going on inside of them, giving them a **framework and a common language**. It has been exciting to see something that works so concretely in the boy's lives – it's putting money right on the line with the students in a very productive manner."

- "We used Chill & Spill with our teachers and school counselors shortly after Hurricane Katrina hit. It allows students to 'attack' their problems without intimidation or fear. Teachers and others who attended Art with Heart's training then taught others how to use the book with their students. **It has made a difference** in the way students perceive their plight and are more understanding that they are not hopeless. It has given them a better understanding and a resolve to deal with the current situation and work towards improving their outlook on life. **They are coping better.**"

- "I use the book to break the ice, facilitate self expression and open up communication in my girl's group. Many of the pages really **compliment and strengthen** activities I already use."

- "Some of the youth I work with are considered dangerous… They are oftentimes afraid to trust and open up for fear of rejection, but I found that Chill & Spill helped them release these inner inhibitions. As a result, **they've learned a lot about themselves** and how to handle their feelings in a positive manner."

- "She had always been told that she was a trouble maker, that she was 'good for nothing.' The EXCLUSIVE INTERVIEW activity asked her questions about her strengths and talents, which made her realize that she did have something to offer. She now is outgoing and participates in activities. She even has a **life goal** now as a direct result of the book: she wants to be a pediatrician."

- "Chill & Spill has literally **changed the way the teens respond** to us and how we respond to them."

- "I had a 16 year old student dealing with severe mental health issues. When I sat down with her to discuss the book, she was in tears. She showed me her drawings and it was immediately clear to me that she was in significant danger of hurting herself and others. She had used the book to draw her feelings instead of act on them. And so **the book became a valuable tool in keeping her safe**. I told her that she could use the book unconditionally, that she did not have to discuss her drawings with me. I have since referred her to a case manager, and she is taking the book with her to therapy sessions to help her deal with some of the more serious issues in her life. After seeing her drawings, **I had a much better understanding of her strengths and weaknesses**."

Sample Proposal For Individual Unit of Study

Below, you will find wording that can be useful for writing a proposal to school administrators to get buy-in.

PURPOSE

To improve the engagement and ability of 8-12 students currently experiencing difficulty in writing currently enrolled at our school

CHILL & SPILL CLASSROOM GOALS

• To improve attendance and engagement in school

• To build social supports and practice interpersonal effectiveness

• To improve appropriate expression and communication

• To develop identity, self-awareness and life goals

RECRUITMENT AND SCREENING

The facilitator is aware of a number of youth currently enrolled in my classes that are at-risk of classroom failure; I will meet with each one-on-one to determine their interest in this unit of study and to screen for appropriateness. Students endorsing active self-harm or assaultive behaviors will be screened out, but referred individually as appropriate.

LOGISTICS

The group will meet weekly during my class during the semester. We will spend a significant amount of time at the start of group to set ground rules including effective ways to negotiate missed class time and the necessity of staying in during lunch if required. If group members wish to continue to meet after the 12 weeks, a meeting time will be determined by the group that does not conflict with the school schedule, such as lunch, before, or after school. The group will meet in room 212. The group size will be between eight and twelve students. The projected start date is October 5.

UNIT CONTENT AND CURRICULUM

The group will be structured around **Chill & Spill**, an interactive journal designed to guide students through the development of self-awareness/self-expression through creative art-making and writing.

COSTS

One copy of **Chill & Spill** per group member @ bulk rate of $11 = $88-132 (Note: it is relevant that each student have his or her own book). Art supplies: $50 for paper, markers, paints, glue.

TOTAL PROJECTED COST: $182.00

Sample Two-Hour Class Agenda

BEFORE: Set up the supplies and materials.

5 min. Open **Chill & Spill** books and describe objectives for the activity of the day.

10 min. Show diverse, non-traditional examples to give them an idea of the wide range of possibilities.

10 min. Help student brainstorm about their personal approaches toward the activity.

5 min. Introduce supplies and demonstrate how to use the medium.

70 min Do the activity.

15 min. Sharing time: personal observations.

5 min. Clean up together • preview what you'll be doing next class.

AFTER: Take photos of finished artwork • evaluate: write down how it went, what you would do differently next time, things you learned, etc.

Sample One-Hour Class Agenda

BEFORE: Set up the supplies and materials.

5 min. Open **Chill & Spill** books and describe objectives for the activity of the day.

5 min. Show non-traditional examples to give them an idea of the range of possibilities. Only use simple supplies which don't need a demonstration on how to use the medium.

45 min. Do the activity.

5 min. Sharing time: personal observations.

AFTER: Clean up • take photos of finished artwork • evaluate: write down how it went, what you would do differently next time, things you learned, etc.

Sample Two One-Hour Classes

If you have limited time, it is possible to extend the activity over two class periods.

CLASS ONE

BEFORE: Set up the supplies and materials.

5 min. Open **Chill & Spill** books and describe objectives for the activity of the day.

35 min. Help student brainstorm about their personal approaches toward the activity. Have students sketch directly in **Chill & Spill**. They will use this as the basis for their art project that will begin next week.

10 min. Sharing time: personal observations.

10 min. Introduce supplies they will use next week and demonstrate how to use the medium.

AFTER: Evaluate: write down how it went, what you would do differently next time, things you learned, etc.

CLASS TWO

BEFORE: Set up the supplies and materials.

5 min. Ask students to re-read what they wrote during the previous class, asking them to highlight the most salient points. They will use this as the basis for their art.

5 min. Show diverse, non-traditional examples to give them an idea of the wide range of possibilities.

45 min. Do the activity.

5 min. Sharing time: personal observations.

AFTER: Clean up • take photos of finished artwork • evaluate: write down how it went, what you would do differently next time, things you learned, etc.

Sample 8 and 12 Week Class Schedules

The **Chill & Spill** Program was created to allow the facilitator maximum flexibility. Below you will find a quick overview of lesson plans for an 8-week or 12-week unit. If you are not constrained by time lines, the activities can, of course, be extended through the semester, summer, or year.

8-Week Curriculum	Week 1	Writing & Drawing Can Help Figure Stuff Out **AND** Best 3 Words...
	Week 2	Your Place or Exclusive Interview*
	Week 3	How I Really, Really Feel
	Week 4	Powerful / Powerless
	Week 5	Action Reaction
	Week 6	Shoulda, Woulda, Coulda
	Week 7	Last Word
	Week 8	Bridges (celebrate their success!)

12-Week Curriculum	Week 1	Writing & Drawing Can Help Figure Stuff Out **AND** Best 3 Words...
	Week 2	Your Place
	Week 3	Exclusive Interview
	Week 4	How Others see Me...
	Week 5	How I Really, Really Feel
	Week 6	Inside of Me
	Week 7	Powerful / Powerless
	Week 8	Action Reaction
	Week 9	Dream Diary
	Week 10	Shoulda, Woulda, Coulda
	Week 11	Last Word
	Week 12	Bridges (celebrate their success!)

* If you begin with the 8-week curriculum, and realize that you have more time, or your students are receptive to the **Chill & Spill** program, then after Week 2, you can easily switch to the 12-week curriculum.

Sample 14-Week Art Class Curriculum

This **Chill & Spill** art class was piloted in the Fall Quarter of 2008 at the Seattle Urban Academy in Seattle. The school is an alternative, private high school for youth who had failed out of the public school system. Ninety percent of students come from low-income/poverty level, single-parent households.

Throughout the semester, twelve students met once a week for two hours with the art instructor, who had been trained in the **Chill & Spill** curriculum. One of the goals for this particular class was to introduce various artistic skills, while developing individual voices for positive self-expression. Students were graded on participation.

To ensure privacy and inspire trust, the instructor kept the student's **Chill & Spill** journals locked in a cabinet in the room in between classes. The journals were then returned to the students to prevent loss or misplacement. If activities from **Chill & Spill** were assigned as homework, students were given a typed sheet with the assignment, which was then tucked into the journal the following week.

See the EXTENSION ACTIVITIES chapter for details on each of the activities.

14-Week Art Class Curriculum	Week 1	Writing & Drawing Can Help Figure Stuff Out **AND** Best 3 Words…
	Week 2	Your Place
	Week 3	Fly Away (<u>Homework</u>: Have students bring in a high-contrast, recent photo for next week's class)
	Week 4	Exclusive Interview, Part 1
	Week 5	Exclusive Interview, Part 2
	Week 6	Me, Myself & I (<u>Homework</u>: Do the **How Others See Me** activity (all three panels). Ask them to take one they are willing to share and recreate as an abstract portrait, using bold lines to represent feelings – not literal, not figurative. This will be for your eyes only.)
	Week 7	How I Really, Really Feel
	Week 8	Circle Journey

	Week 9	Inside of Me (Homework: **Personal Lifeline** in **Chill & Spill** journal, using color to assign to positive events, and another color to describe negative events. This will be kept private, but you will need to review just to make sure they completed it.)
	Week 10	Powerful / Powerless (Homework: Do **Action Reaction** on own.)
	Week 11	Shoulda, Woulda, Coulda (Homework: Using prompts from **The Last Word** write a private letter to a habit you would like to break. Ask students to bring in a pair of old shoes that they don't wear much anymore (they have to still fit)
	Week 12	Bridges
	Week 13	Make-Up Work Day: Allow youth to finish up artwork they haven't completed yet (you must have all supplies available). Check in on homework assignments: did they complete them all? Also give them a chance to transfer any of their loose sheets they did as homework into the journal. Wrap up by asking students to share which activity seemed most helpful to them, most fun or most surprising to them. Have them fill out an evaluation form that you will share with Art with Heart (available online). Provide snacks, if appropriate.
	Week 14	Gallery Event: Students gather to show off their favorite work at the gallery. Students invite friends and family, the school invites other students and staff and Art with Heart invites volunteers and donors. Cookies and punch are provided and students get to wear "**Chill & Spill** Artist" badges.

14-Week Art Class Curriculum, cont.

Student Evaluation Form

Please complete this survey so we can learn what you think about Chill & Spill. Your answers will be confidential, so please be honest Thank you for your help! Please return to your teacher who will forward onto Art with Heart, the creators of "Chill & Spill."

My name is:

I am ❑ Male ❑ Female I am _____ years old and in _____ grade.

Before I started using Chill & Spill, I felt *(circle the number that describes how you felt):*

| 1. Happy | 2. | 3. Okay | 4. | 5. Icky |

Some of the things I struggle with include:

After I worked with Chill & Spill, I felt *(circle the number that describes how you feel):*

| 1. Happy | 2. | 3. Okay | 4. | 5. Icky |

While using Chill & Spill, this is what I learned about myself:

TEACHER: *Please photocopy these two pages to give to each of your students. Mail to Art with Heart, P.O. Box 94402, Seattle WA 98124-6702.*

Student Evaluation Form

Read each line and check if the item is true:

When doing Chill & Spill, I...

	(1) Strongly Disagree	(2) Disagree	(3) Agree	(4) Strongly Agree
8. learned things about myself.	☐	☐	☐	☐
10. dealt with things that were painful, scary or difficult.	☐	☐	☐	☐
12. liked my Chill & Spill facilitator.	☐	☐	☐	☐
13. liked the Chill & Spill book.	☐	☐	☐	☐

Chill and Spill...

	Strongly Disagree	Disagree	Agree	Strongly Agree
14. taught me things about me that I wasn't aware of before.	☐	☐	☐	☐
15. helped me figure out my feelings.	☐	☐	☐	☐
16. encouraged me to talk about my life.	☐	☐	☐	☐
17. helped me deal with hard things in my life.	☐	☐	☐	☐
18. made me feel better about myself or my situation.	☐	☐	☐	☐
19. helped me figure out what I want in life.	☐	☐	☐	☐
20. helped me make better choices for my life.	☐	☐	☐	☐

What else would you like to tell us?

An Educator's Companion to Chill & Spill

Sample Media Release Form

On this date of _____ *date / year* _____, I authorize and give full permission
to _____ *your school's name* _____ and Art with Heart, to use my artwork,
or scanned/photographed likeness for the purposes of showing other classes, and/or
for Art with Heart's marketing or fund-raising purposes. I understand that I am
to receive no compensation of any kind as a result of any printing, internet usage,
broadcasts, or other non-broadcast uses thereof. I have _____ *your school's*
name _____ and Art with Heart's assurance that my likeness/image will not be used
in an exploitative or derogatory nature.

_____ *Your school's name* _____ and/or Art with Heart shall maintain complete
ownership, copyright, including domestic or foreign and the exclusive right to
make such use of the artwork as _____ *your school's name* _____ and/or Art with
Heart wishes, including (but not limited to) the right of display, reproduction and
distribution in all media and the right to create, perform, display and distribute
derivative works thereof.

Please check off all that apply:

❏ I allow _____ *Your school's name* _____ and/or Art with Heart to use any
 photos, scans or video taken of me or my artwork

❏ I allow _____ *Your school's name* _____ and/or Art with Heart to keep my
 artwork

_____ _____

Date Printed name of participant

_____ _____

Age of Participant Participant/Guardian Signature

_____ _____

Telephone Teacher's Signature

Please return this form to Art with Heart at P.O. Box 94402, Seattle, WA 98124-6702

Alignment with Academic Standards & Benchmarks

In the charts that follow, Chill & Spill activities are aligned with the McRel Academic Benchmarks, the Washington State Essential Academic Learning Requirements and the Colorado Department of Education Social Skills guidelines.

CHILL & SPILL ACTIVITY	THEME(S)	ACTION	WA State EALRs	McRel Benchmarks	Social/Emotional
Writing and Drawing Can Help You Figure Stuff Out	Taking ownership of the book, learning about free-flowing thoughts & feelings.	Write down thoughts, goals, get used to writing about self	Arts 1, 2, 3, 4; Communications 1.1, Writing 3.1	Arts Connections; Life Skills/Self-Regulationi 1	Empathy; Setting Boundaries
The Best Three Words to Describe Me	Building sense of identity, raising self-esteem, setting goals.	Write three words that describe you. Write a short story about you -- fill in the blanks.	Communications 1.1; Writing 2.1	Health 4; Life Skills/Working with Others 4, Self-Regulation 2	Self-awareness; Self-management; Recognize personal qualities
Your Place	Creating a real or imaginary "safe place" to go to when things get difficult.	Create your own "safe place" -- what does it look like? feel like?	Art 1,2,3	Art Connections; Language Arts Writing 2	Setting Boundaries; Anger and Impulse Management
Fly Away	Explore the connection between nature and feelings. Visualize yourself as a seed that has been picked up by a bird. You find a safe place, take root and start growing... what kind of plant are you? Who is your "gardener"?	Draw your growth as if you were a plant – who cares for you?	Art 1,2,3	Art Connections; Health 2,4; Behavioral Studies 4	Empathy, Reconize external supports
Exclusive Interview	Building a sense of identity and self-esteem. Create healthy fantasies, manifest a desired reality.	You're a reporter for a celebrity magazine, interviewing...yourself.	Communications 1.1, 2.1; Writing 2.1, 2.2	Behavioral Studies 1,4; Health 4; Life Skills Self-Regulation 2, 5	Empathy; Expectations in Relationships; Recognize personal qualities

CHILL & SPILL ACTIVITY	THEME(S)	ACTION	WA State EALRs	McRel Benchmarks	Social/Emotional
Me, Myself, and I	Valuing and exploring identity.	Create a collage from magazine images·that represents who you are.	Art 1,2,3,4	Art Connections; Health 4; Life Skills/Self Regulation 2, 4	Empathy; Verbal/ Non Verbal Communications
How Others See Me/I See Myself/I Want to Be Seen	Self awareness, creating a reflective distance, identifying how positive connections can be blocked.	Write, draw, doodle, collage on three pages especially designed to give privacy to the artist.	Art 1,2,3,4	Art Connections; Health 4; Behavioral Studies 4; Life Skills/Self Regulation 2, 4	Empathy; Setting Boundaries; Expectations in Relationships
...and How I Really, Really Feel	Finding undiscovered feelings via free association.	Write thoughts using prompts like "I want...", "I hope...", "I expect..." etc.	Communications 1.1; Writing 1.1, 2.2	Health 4; Behavioral Studies 4; Life Skills/Self Regulation 2	Empathy; Recognize personal qualities; Self awareness
Circle Journey: Mandala Part 1	The process of self-discovery, change, rebirth and renewal.	Color in a mandala, using colors that represent your feelings about the seasons.	Art 1,2,3,4	Art Connections; Life Skills/Self Regulation 3	Empathy; Verbal/ Non Verbal Communications
Circle Journey: Mandala Part 2	Identity and working through fear of change: increase self awareness and self-acceptance.	Create a personal mandala: the center contains images of things you're afraid of, the next ring things you do or don't do because of fears, outer ring contains ways to deal with fears and overcome them.	Art 1,2,3,4	Art Connections; Health 4; Behavioral Studies 1,2,3,4; Life Skills/Self Regulation 2, 3, 5	Empathy; Conflict Management; Verbal/ Non Verbal Communication, Expectations from Relationships

CHILL & SPILL ACTIVITY	THEME(S)	ACTION	WA State EALRs	McRel Benchmarks	Social/Emotional
Inside of Me	Building a feelings and thoughts vocabulary.	A multi-day activity (week long): make a map of your "heart"--things that your are feeling each day.	Art 1,2,3,4; Communication 1.2; Writing 1.1. 2.2	Art Connections; Health 2, 4; Behavioral Studies 1,2; Life Skills/Self Regulation 2, 5	Empathy; Expectations from Relationships
Personal Lifeline	Create recognition of pattern and perspective by honoring life events.	Create a personal history "lifeline" (timeline). Start with the year you were born and end on today's date.	Art 1,2,3,4; Communications 1,2; Writing 1.1, 2.2	Health 2,3,4; Life Skills/Self Regulation 1, 2, 3. 4; Life Skills/ Working with ohters 4	Empathy; Decision Making; Recognize external supports
Powerful, Powerless	Developing personal symbology, viewing self as powerful and capable.	Collage a mix of images to represent yourself when you are -- and when you aren't -- in control -- powerful.	Art 1,2,3,4	Art Connections; Health 3, 4; Life Skills/Self Regulation 2, 3	Empathy; Conflict Management; Demonstrate decision-making skills
Action, Reaction	Identity and working through fear of Identifying "hot buttons" or triggers that you feel out of control.	Create a chart identifying things that "trigger" you and the reactions you have.	Communication 1.1, 2.1	Health 4; Behavioral Studies 2,3,4; Life Skills/ Self Regulation 1, 2, 3, 4, 5, 6	Conflict Management; Anger/Impulse Management; Setting Boundaries
Dream Diary	Becoming aware of feelings, self-awareness and self-discovery.	Keep a dream diary. keeping track of impressions, words, images, textures, colors that you remember	Writing 1.1, 2.1, 2.2	Health 4; Language Arts Writing 2; Life Skills/Self Regulation 1	Empathy; Develop self-awareness

CHILL & SPILL ACTIVITY	THEME(S)	ACTION	WA State EALRs	McRel Benchmarks	Social/Emotional
Shoulda Woulda Coulda	Identify and externalize negative thoughts (the "inner critic"). Identify thoughts that are helpful and hurtful.	Write down three positive things and three negative things that you tell yourself about yourself. Pick the message that bothers you the most and explore it. Give it a goofy name, draw it as a cartoon...	Writing 1.1, 2.1, 2.2	Health 4; Life Skills/Self Regulation 1, 2, 3, 4, 5	Empathy; Identify and manage one's emotions and behavior; Goal making; Recognize personal qualities
The Last Word	Healthy communication, processing grief.	Write a letter to someone saying everything you wanted to say, but didn't, so you can have the "last word."	Communication 1.1; Writing 1.1, 2.1, 2.2	Health 4; Behavioral Studies 3; Life Skills/Self Regulation 2, 3, 6	Empathy; Identify and manage one's emotions and behavior
Bridges	Defining a problem with shapes, words, textures and moving from problem-focused to solution-focused thinking.	Create a bridge: you are on one side and where you want to be is on the other side. Take steps to the other side...what will you be thinking and feeling when you get to the other side?	Communication 1.1	Health 4; Behavioral Studies 3; Life Skills/Self Regulation 1, 2, 3, 4, 6	Decision Making; Goal Setting; Develop self-awareness

An Educator's Companion to Chill & Spill

Glossary of Terms

ABSTRACT ART is where the combination of form, color and line create a nonobjective or nonrepresentational piece that is either a slight, partial, or complete alteration of realism. The term is very broad umbrella under which a wide variety of art styles are defined: it includes abstract expressionists, cubists, fauvists, dadaists, constructivists, etc. Abstract artists may begin with a figure or a still life, but then simplify, exaggerate, or stylize it in order to project a feeling for the subject rather than an exact likeness. Abstract art is a wonderful place for students to begin because they do not need to try to reproduce something, but they use their imagination, lines, colors, and shapes to create a unique piece of art. It is very forgiving of "mistakes," allowing students to feel pride in their accomplishments.

ART MORGUE is a reference file containing reference materials, such as your sketches, doodles and ideas for unexpected and possible future use. Oftentimes, a sketchbook, binder, or file box is used to gather favorite images, textures, reference materials, magazine articles, text examples, fine art reproductions – whatever the eye is attracted to. This is an excellent way to continually have inspiration at your fingertips.

ART THERAPY is a type of psychotherapy that uses imagination, art-making and creativity to increase emotional well-being. Art therapy combines traditional psychotherapy theories and techniques with specialized knowledge about the psychological aspects of the creative process, especially the affective properties of different art materials. As a mental health profession, art therapy is employed in many different clinical settings with many different types of patients. Art therapy is present in non-clinical settings as well, such as in art studios and workshops that focus on creativity development.[11]

ASSEMBLAGE ART is a three-dimensional artistic composition or sculpture made from assembled found objects. The objects are organized together into a unified whole, often made up of unrelated and discarded objects. The term was coined by Jean Dubuffet in the 1950's, and is applicable to collage, photomontage, and sculptures. This technique is environmentally friendly and turns everyday objects into a three-dimensional artistic piece. Some assemblages are framed within a box which serves as a frame for the art. Students use cast-off objects as symbols to represent

11 http://www.psychology.org

personality traits and experiences.

COGNITIVE-BEHAVIORAL THERAPY (CBT) has been demonstrated by many research studies to be the most effective approach for a variety of psychological problems. In CBT, the therapy relationship is collaborative and goal-oriented, and the focus is on emotions, thoughts, and behaviors. The goal is for a person to develop more realistic and rational perspectives, and make healthier behavioral choices, as well as to feel relief from negative emotional states. Specific techniques, strategies and methods (cognitive restructuring, relaxation exercises, exposure work, assertiveness training, and more) are used to help people to improve their mood, relationships and work performance.[12]

COLLAGE (from the French: "Coller," to glue) is a work of art, made from an assemblage of different forms, creating a new whole. A collage may include torn newspaper, ribbons, colored or hand-made papers, portions of other artwork, photographs and other found objects, glued to a piece of paper or canvas. Both Georges Braque and Pablo Picasso coined this term in the beginning of the 20th century when collage became a distinctive part of modern art. Other examples can be found in the works of Henri Matisse, Juan Gris, Romare Bearden, Nick Bantock, Joseph Cornell, Robert Rauschenberg. See the TIPS & TRICKS: COLLAGE section in the EXTENSION ACTIVITIES chapter for additional information.

CONTOUR LINE is the inside or outside edge of an object. It is used to visually describe the boundary, gesture or movement that is expressive of an idea, opinion, or emotion.

EMOTIONAL INTELLIGENCE describes the ability to perceive, assess, integrate and positively regulate and manage one's emotions, even negative ones, to promote personal growth and help achieve intended goals.13 The skills which an emotionally intelligent person utilizes include self-awareness, self-management, social awareness, and relationship management

EXPRESSIVE LINES are ones that indicate emotion and feelings through drawing or wire.

FOUND OBJECTS: "junk" that isn't organic or perishable (see the MATERIALS & TECHNIQUES section in Chapter 3 for more information)

12 http://www.cognitive-therapy-associates.com
13 Bradberry, Travis and Greaves, Jean. (2005). The Emotional Intelligence Quick Book. New York: Simon and Schuster.

FREE ASSOCIATION is the spontaneous, uncensored outpouring of thoughts, out loud or in writing, regardless of how apparently unimportant or potentially embarrassing the subject matter may be.

FREE-WRITING (also called stream-of-consciousness writing) is a writing technique in which a student writes continuously for a set period of time without regard to spelling, grammar or topic. The writer is instructed to continue to write even if "stumped," filling in their blank thoughts with fillers like "I don't know what to say" or "blah blah blah." It produces raw material, and allows the writer to avoid self-criticism. This technique is also used by some writers to collect their initial thoughts and ideas on a topic, and is often used as a preliminary to more formal writing.

GROUND RULES are a common set of agreed standards of behavior in the group or classroom, that allow meaningful dialogue to proceed without criticism. They prevent undesirable behaviors that might otherwise threaten everyone's learning and comfort level.

ITEMS OF SUSPENSE are made up of found objects or nontraditional materials that can be added to the artwork or will alter the artwork in some way. Examples of these unexpected items could be a fork that can be used to scratch away paint to reveal an underlayer of canvas or previously dried color. These items are used to inspire renewed interest in the project and allow the student to continue adding to their creation.

MALADAPTIVE BEHAVIOR is behavior that is unsuitable, counter-productive, or ineffective in a given situation and interferes with or sabotages mental, academic, social or personal skills. Some maladaptive behavior can be an attempt to communicate stress or to avoid conflicts between body and psyche.

MANDALAS are usually a complex, circular design divided into four or eight parts. The word is Sanskrit for "healing circle," "essence" or "wholeness." In art therapy, they are often used as a centering activity to help reduce anxiety. They are found in nature, architecture, art and religious cultures throughout time (Hindu, Native American, Buddhist and Christian).

MEDIA (plural of **MEDIUM**) are the materials and techniques used by an artist to produce a work (for example: in drawing, the media could be colored pencil, markers or oil pastel; in painting the media could be acrylic or watercolor).

MIND MAP is a graphic diagram arranged around a central idea or key word, representing ideas or tasks, to help generate, visualize, or structure ideas. It is used to help clarify thinking, problem solving, decision making, and writing.

MULTI-FLOW MAPS are visual aides that help illustrate a cause and effect relationship. This helps them sequence what caused something to happen and notice the results of that event. Sometimes there are effects that, in turn, influence the original cause. This circular cause and effect relationship is called a feedback loop.

NARRATIVE THERAPY is a form of psychotherapy which utilizes the "stories" through which people understand their life experience. Their stories contain meaning for the individual, based on his or her interpretation of events and experiences. The meaning in turn influences him or her, and can have significant effects and consequences for the person. Through re-telling stories in therapy, one can find alternative ways of expressing the story, as in taking a different angle with a different thematic meaning, selecting events and experiences that are consistent with that thread, and developing the narrative accordingly. The therapist seeks to engage the person in richly describing and strengthening these new, preferred stories. The alternative stories that emerge during collaborative therapeutic conversations with the therapist help the person to break free from the influence of his or her problems (or problematic stories), and they are in line with how the person would like to be and live his or her life.[14]

OUTSIDER ART, closely linked to Naive Art and Folk Art, is defined by art created by self-taught artists who are outside of the mainstream art world. Despite the lack of formal training, the awkward drawing and perspective celebrates pure and authentic creative impulses and is often defined by a strong use of pattern, unrefined color, and simplicity. Much outsider art illustrates extreme mental states, unconventional ideas, or elaborate fantasy worlds. This broad definition can also include artwork from "primitive" societies, mental patients or children's artwork. A key distinction between folk and outsider art is that folk art typically embodies traditional forms and social values, where outsider art departs from society's mainstream.

14 Ibid

An Educator's Companion to Chill & Spill

REBUS is a type of word puzzle that uses a visual representation of words in the form of pictures or symbols.

REFLECTIVE DISTANCE is an art therapy term used to define the cognitive distance between the art experience and the individual's reflection of that experience; the ability to verbalize what they visually created; the ability to externalize feelings or traumatic events through non-direct means;[15] the ability of time to give perspective on a situation.

THUMBNAIL SKETCH is a very small, rough sketch that is used to help quickly work out a variety of ideas and creative options before choosing the best solution and fully committing to one. Creating numerous thumbnail sketches is a crucial part of the brainstorming aspect of any project, as it allows the artist to work out concepts before committing. This is essentially the process of rapid visualization. An artist may quickly sketch two dozen rough ideas this way until he/she finds the idea or layout they want to explore further. Thumbnails also allow the artist to develop the skill of "thinking with your pencil" to communicate, organize and present ideas on paper.

TYPOGRAPHY is the art and techniques of arranging type or designing type using a variety of illustration techniques. Typography is created by typographers, graphic designers, art directors, and comic book artists. It can range in formality from medieval illuminated calligraphy to subway graffiti tags. Typographers use the fact that letters are not just abstract notions, but are carriers of meaning – using words as images. They are also real, physical shapes. Modern typographers oftentimes use "expressive typography" to create additional meaning or emphasis on a particular word. Designers can use striking contrasts of size, style and position of type to get attention in order to impart a message. By making the image visually rewarding, the reader's curiosity is invited in. Examples of famous typographers include: Herb Lubalin, Jack Stauffacher, Massi, Neville Brody, David Carson, Jan Tschichold, and House Industries.

VISUALIZATION or **GUIDED IMAGERY** is a relaxation technique that brings someone on a calm and peaceful "journey" or helps create a positive mental picture of desired life changes. Evidence shows that the mind responds not only to reality, but to our thoughts about reality. The use of guided imagery can help reduce emotional arousal and can re-frame

15 Kagin, S. L. & Lusebrink, V. B. (1978). The expressive therapies continuum. The Arts in Psychotherapy, 5(4), 171-180

circumstances through metaphor. Guided imagery is often used to help a number of chronic conditions, including headaches, stress, high blood pressure, and anxiety. If used in medical treatment, the patient may visualize his/her body as healthy, strong, and free of the specific problem or condition. It is helpful for students who may need to "rehearse" in their imagination behaviors and/or feelings that they need to change. It has successfully been used to reduce stress, stimulate the immune system and relieve the effects of both physical and emotional illness.

Index

An Educator's Companion to Chill & Spill

ART WITH HEART

healing kids through creativity

Art with Heart is a nonprofit organization that empowers youth

in crisis through therapeutic books and programs that foster

self-expression. Traumatic situations can lead to emotional

suffering, but Art with Heart believes that by providing a

creative and healthy outlet, youth will not just survive, but thrive.

Support our work by donating today at **www.artwithheart.org**

An Educator's Companion to Chill & Spill

RE-ORDERS

Please visit our website at www.artwithheart.org to purchase
any of our books, including our books for youth dealing with health
crises. Purchase orders are accepted online, as well as credit cards.

CHILL & SPILL

Chill & Spill Journal: 14.2 oz, 5.5"x8.5", 37 full color/70 blank pages.
Available in individual and bulk rates (in increments of 8)

THERAPIST'S COMPANION

Supports therapists using **Chill & Spill**

EDUCATOR'S COMPANION

Supports creative people who would like to learn how
to use their talent to work with youth

ART WITH HEART

P.O. Box 94402, Seattle, Washington 98124-6702

206.362.4047

email: info@artwithheart.org

w w w . a r t w i t h h e a r t . o r g

All proceeds help children in crisis.

ART WITH HEART
healing kids through creativity

PLEASE TAKE A MOMENT
TO FILL OUT THE FOLLOWING

AND SEND IT TO US:

Art with Heart | P.O. Box 94402, Seattle, WA 98124-6702

email: info@artwithheart.org | www.artwithheart.org

OR

SIMPLY FILL IT OUT ONLINE AT:

www.artwithheart.org/chillandspill

and click on the survey link!

Thanks!